快城快客　　2008上海双年展国际学生展作品选
Selected Works of International Students' Exhibition
of Shanghai Biennale 2008
吴长福　陈永群　主编

中国建筑工业出版社

序

"快城快客",两个"快"字直指当代的城市变幻特征,一为城市物质形态日新月异的"快",二为城市主人、客人接踵而至的"快"。

2008年的上海双年展国际学生展,值北京奥运盛会,世人皆赞,14亿国人又在拥抱世界之时,沉浸在内心的欢快之中,给了此次"快"的命题更多了一层新的诠释。

"城"与"人",这一对城市发展命题,以及在城市化背景下,跨区域、跨文化流动下的大众文化与微观政治的讨论、批判和反思,昭示着上海双年展已经从始创之初的沙龙形式,一步步地走入现实社会。其所传达的当代艺术对社会现实的映射、态度和思辨,使得这届双年展深具现实性、社会性和学术性,因而也格外值得期待。

同济承办上海双年展国际学生展已历三届,"主展—学生展" 以及"设计—艺术"对话的模式,加之全球学子积极的参与,影响渐隆,已然成为上海双年展的一大特色。

本书收录的作品来自14个国家和地区,是当代艺术和设计界新生代的集体呈现。阅读他们回应"快城快客"这一主题的与成熟艺术家们趣味迥异的解答,实在颇为受用。秋天还未到来,我们已然庆贺丰收!

感谢为国际学生展挥洒汗水、热情和创意的学生们和指导教师们!

这个夏天欣然命笔作序,岂不快哉!

吴志强
同济大学建筑与城市规划学院 院长
2008年8月20日

Preface

The Selected Works of International Students' Exhibition of Shanghai Biennale 2008 are all collected and ready to be published, when the Beijing Olympic Game are going ahead like wildfire. I'm so glad and proud to write this preface in the year 2008, a quite eventful year, when people all over the world focus their eye on China. This summer, after encountering and recovering from the 5.13 earthquake,1.4 billion Chinese people are here to show our confidence, celebrate our victory and to embrace this world, with the Olympic spirits which refer to "Faster, Higher, Stronger".

Two weeks later, Shanghai Biennale 2008, an international grand gathering of contemporary art, is to raise the curtain again. The theme of this year, TRANSLOCALMOTION, which gives the artists a thorough vision on the big currency of the population and development in the city. Against the background of the urbanization, the theme aims to dicuss, criticize and reflect on the micro-political viewpoint and the popular culture with the trans-regional population and the cross-cultural flow. The theme shows that Shanghai Biennale have been stepping into the reality, from the initial salon days. It makes this year's exhibition roots deep into the social and academic reality, and converts out the reflection, attitude and thought to the public in this contemporary way, so that we are looking forward to it so much.

This is the third time that Tongji University undertakes the International Students' Exhibition of Shanghai Biennale. It has already turned out to be a feature of the Shanghai Biennale with its growing impact. Students from all over the world participate in the exhibition under the two dialogue modes: from the main exhibition to students' exhibition, from design to art. And, there are works from 14 countries and regions collected in this book , presenting us an excellent show by the new generation of contemporary art and design.
When reading their responds to the professional artists in different perspectives and ways in this book, we found it quite beneficial to us. In the end, I want to express my sincere gratitude to the students and the teachers who had drain their brains on the innovation and dedicate their enthusiasm to the students'exhibition.

Finally, great congratulations to our big harvest in this summer!

WU Zhiqiang
Dean and Professor of College of Architecture and Urban Planning, Tongji University
20 th August, 2008

中国
China

— 中央美术学院
China Central Academy Of Fine Arts

1 呼吸
 Breath

2 2008.1.1, 2008.12.31
 2008.1.1, 2008.12.31

3 涉江
 Wading across the river

— 清华大学
Tsinghua University

4 快城快蚁
 Translocal Ants

— 中国美术学院
China Academy of Fine Arts

5 寄存
 Depositing

6 移动的家
 The Mobile Home

7 一只鸟和他的幻想空间
 A Bird and It's Imagination

8 私人生活
 Private Life

9 骑楼概念设计
 Conceptual Design of the Sotto Portico

10 市井园林
 Civilian Garden

11 警惕"快餐文化"
 To Be on the Alert for 'Fast-food Culture'

12 私人空间
 Personal Space

13 十厘米
 10 cm

14 火药山水
 The Landscape of Gunpowder

15 惊蛰
 Excited Insects

16 天下没有不散的筵席
 All Good Things Come to an End

17 国际旅游者之经典废墟一 / 国际旅游者之经典废墟二 / 国际旅游者之经典废墟三
 Classical Ruins for International Travellers Ⅰ / Ⅱ / Ⅲ

18 理想物
 The Ideal

19 取舍万殊
 Differences

20 1:15
 1:15

21 夏日炎炎
 Summer Day

22 小地鼠不知道
 Mole Don't know

23 火车开往北京
 The Train is Leaving for Beijing

24 老房子
 Home, In Memory

25 轮回
 Samsara

26,27 呼吸
 Breath

— 同济大学
Tongji University

28 聚
 Gather

29 飞走的留言条
 Flying Notes

30 Finger@Shanghai
 Finger@Shanghai

31 场
 Field

32 城市一角
 A Corner of the City

33 硬币观·上海
 Life with Coin @ Shanghai

34 像蝙蝠一样相对尖叫
 Relatively Screaming Like Bats

35 生活万花筒
 REFLECT the Blooming City

36 Repay
 Repay

37 借读·笔尖
 Transient · Nib

38 方言,不丢
 Dialect, Never Be Discarded

39 城市建设者
 City Erectors

40 空间时间– 钟
 Space and Time – the Clock

41 忙·茫
 Busy · Vague

42 微观宙
 Micro – Universe

43 卡带·记忆 – 卡带日记
 A Rolling Diary

44 传递
 Delivering

45 微小城市
 The Tiny City

46 都会表情
 Metropolis · Expression

47 World I
 World I

48 瓶·常人
 Bottle · People

49 Level B
 Level B

50 快城快递
 Translocal Express

51 惑·获
 Confusion or Harvest

52 边缘城市
 Marginal Urban Living Space

53 自力更生: 24小时简易自救抗震棚设计建造实验
 Self-dependence: A 24-hour Cardboard Quake-proof Shelter Design and Construction Lab

54,55 鸟巢
56,57 Bird's Nest

58 第101个城市
 The 101st City

— 香港理工大学设计学院
School of Art and Design of Hong Kong Polytechnic University

59,60,61 活络
 ACtive Context

— 天津美术学院
Tianjin Academy of Fine Arts

62 大风景 / 线的存在状态之嬷嬷人
 Great Scenery / Mama – the Existing State of Line

63 精神异托邦 / 城市——求同存异
 Spiritual Eutopia / City – Seeking Common Ground While Accepting the Existing Differences

— 广州美术学院
Guangzhou Academy of Fine Arts

64 有物混成
 The Mixture

65 地球——人
 The Earth – Human Beings

日本
Japan

— 汕头大学长江艺术与设计学院
Shantou University Cheung Kong School of Art and Design

66 城市的身体
Body of the City

67 记忆·空间
Memory · Space

— 东华大学
Donghua University

68 家
Home

69 小地方，大城市
Tiny Place, Big City

70 走进农民工，情系留守儿童
Care for the Off-farm Workers and their Children

— 东南大学
Southeast University

71 "你来了，我走了"
'You Come, then I Go'

72,73 记忆·空间（水墨东阳）
Memory·Space

— 上海戏剧学院
Shanghai Theatre Academy

74 你的记忆，我的地图
Your Memory, My Map

— 上海大学
Shanghai University

75 大建筑
The Grand Architecture

76,77,78,79 上海市第八棉纺厂周边地段城市设计
An Industrial Building Re-used Design

— 上海大学
Shanghai University
华东师范大学
East China Normal University
合作

80 都会·表情
Metropolitan · Expression

— 广东商学院
Guangdong University of Business Studies

81 闯荡
Flying and Breaking

— 西安工程大学
Xi'an Polytechnic University

82 引想
Quote Thinking

— 西安建筑科技大学
Xi'an University of Architecture and Technology

83 都市传感器 – 为学生设计的居住单元 / 西安钟鼓楼广场时间线
The City Sensor – The Dwelling Unit Designed for Students / The Time Line of Xi'an Drum-Tower

— 苏州工艺美术职业艺术学校
Suzhou Art and Design Technology Institute

84 101窗
101 Windows

— 华侨大学
Huaqiao University

85 蓝色纸飞机
The Blue Paper Plane

— 山东艺术学院设计学院
Shandong University of Art School of Design

86 脉动
The Pulsating Movement

— 杭州师范大学
Hangzhou Normal University

87 拆·台
Destroy the Stage

— 千叶大学
Chiba University

88 Tsukumo-gami
加拿大世界汽车设计比赛

89 Research on Styling of Home PC
关于家用个人计算机款式的研究

90 Proposal of A Bicycle Using Elasticity Behavior
自行车设计

91 Making of Tessellation
镶嵌装饰的制作

92 Rental Vehicle in A Large-scale Park
大型公园里的出租机动车

93 Comfortable to Use Camera Grip
舒适的相机抓握

94 Warabo
伊豆

95 Engawa
鲽鱼

96 Living Space
居住空间

英国
UK

— 英国皇家艺术学院
Royal College of Art, London ,UK

97 Hold On
 抓住

98 Suspended Chaos
 悬浮的无序

99 BenD / A Chair that Deforms when not in Use
 BenD／变形椅

— 伦敦艺术大学中央圣马丁艺术与设计学院
The University of the Arts London
Central Saint Martins College of Art &Design

100 Memory · Space
 记忆·空间

— Birmingham Institute of Art and Design
伯明翰艺术设计学院

101 Missing Mind
 缺失的思想

— 邓迪大学
University of Dundee

102 Human connectedness
 人的连通性

103 Portrayal of Urban Violence through Textiles
 织物都市暴力写照

104 FUSE20: Space
 FUSE20: 空间

105 Memory - Space
 记忆-空间

106 Non-Places
 虚无空间

107 Architecture at the Coast
 海岸边的建筑

108 Sky Road
 天路

109 An Archaeology of the Present
 现代考古学

110 City as Narrative Realm
 城市，作为一种叙述领域

澳大利亚
Australia

— 皇家墨尔本理工大学
School of Art RMIT University

111 Untitled
 无题

112 Exhibition Installation
 展览装置

113 Recombination: Towards Contemporary Group Form
 对当代组织形式的重新整合

114 Entity 4
 存在 4

115 Transparent House Image 2
 透明房屋图像 2

116 Inside and Outside 3
 内外 3

117 Reifications
 具体化

118 Wall
 墙

119 Seedtime: a Dynamic (Urban) Organisation
 播种时期：一个有活力的城市组织

120 Where Things Stop and Start
 事物开始与结束的地方

121 Negotiating Space - An Interior Practice
 洽谈空间 —— 室内设计练习

122 Architectural Design and Discourse
 建筑设计与讲述

123 Anti-memorials: Re-thinking the Landscape of Memory
 反纪念：关于记忆景观的再思考

124 Terroir As a State of Mind
 作为一种思维状态的Terroir

125 Materialising the un-Australian
 物质化的联合国澳大利亚

— 澳大利亚悉尼科技大学设计学院
University of Technology, Sydney

126 书志目录平面设计
 Biblio Graphic

意大利
Italy

— 意大利米兰理工
Politecnico di Milano

127 All In a Suitcase
 一切都在行李箱里

法国
France

— 法国南特高等设计学院
L'école de Design Nantes Atlantique

128 Interactive Design Project
 交互设计项目

芬兰
Finland

— 芬兰赫尔辛基艺术设计大学
The University of Art and Design Helsinki (TaiK)

129 The CityCab
 城市出租车

130 The Sauna Bus
 桑拿巴士

丹麦
Denmark

— 丹麦科林设计学院
Designskolen Kolding

131 Magic Shoe/
 Ten Bikes: a Co-operative Project
 魔鞋／10辆自行车合作项目

美国
USA

— 纽约大学
New York University

132 Central Park, as a Living Organism
纽约中央公园规划

— 艺术中心
Art Center

133 Bus of the Future: 2050 / Shenzhen Mobilty
2050年的未来巴士／深圳流动性

134 Indy Project / Deus ex Machina
印地赛车联盟赞助项目／舞台机关送神

厄瓜多尔
Ecuador

— 里托瑞尔高等理工学院
Escuela de Dise.o y Comunicación Visual – ESPOL

139 Posters for Collective Reconciliation
为集体和解而作的海报

加拿大
Canada

— 莱斯布里奇大学
University of Lethbridge

142 Communication Model
沟通模型

荷兰
Netherlands

— 荷兰鹿特丹大学德库宁设计学院
Fine Arts Willem de Kooning Academy, Hogeschool Rotterdam

140 Embroideries
刺绣

141 The Myth of a New Nation
一个新民族的神话

瑞士
Switzerland

— 瑞士卢塞恩艺术设计大学
Lucerne University of Art and Design (HSLU)

135 Common Social Problems in Megacites, Hypercities
大城市共同的社会问题

科威特
Kuwait

— 科威特大学
Kuwait University

143 Mobile Phone Booth
移动电话亭

144,145 TeaCoffee
茶咖啡

瑞典
Sweden

— 瑞典国立艺术设计学院
Konstfack Universuty Colledge of Arts Crafts And Design

136 Flower2.0
花 2.0

137,138 The Embedded Media Master Elective 2008
嵌入式媒体设计2008

德国
Germany

— 柏林艺术大学
The Berlin University of the Arts

146,147 Future Cookies
未来饼干

呼吸
Breath

作者　高鹏　黄松　刘遥　张一凡　高振鹏　张婧雅

作品以气候作为切入点。
在两个温差很大的房间内，人们的皮肤会对强烈的高温和低温有剧烈的反应，对温差切身的感受将促使观众在两个房间内穿梭，寻找使身体和心理舒适的位置，以此调节自己的适应能力。
作品探讨在新的和特殊的环境下人们所面临的适应和选择的问题，藉此将迁徙的问题集中化表现。以身体的反应点出人们在城市迁徙过程中复杂的心理变化。

指导教师　苏新平　李帆

表现形式　装置

展品尺寸　10m×5m×3m

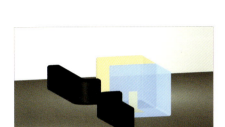

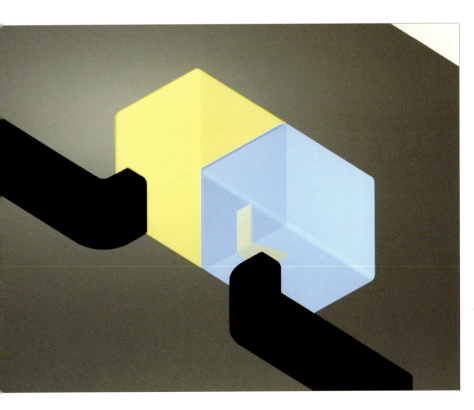

Author　GAO Peng HUANG Song LIU Yao
ZHANG Yifan GAO Zhenglin
ZHANG Jinya

Work Theme Description
The work presents the question s that we have to face when urbanism becomes everyone's dream.The identity of human seems to be big issue to or believes to the future.

Faculty Tutor　SU Xinping LI Fan

Presentation Media　Installation

Exibits Dimension　10m×5m×3m

2008.1.1, 2008.12.31
2008.1.1, 2008.12.31

作者　叶云

作品主题
通过作者对自己一年所食用食品遗迹的收藏行为，表述现代都市一切事物包括人，在统一标准下生产制作、输出、高速消费、迅速消解的命运。用消费时代的食品生产、保质、消耗期限，述说现代人同样的命运。

指导教师　王中　李震
表现形式　装置 现成品展示
展品尺寸　240个直径8cm的水瓶 约1.6m × 30m

Author　YE Yun

Work Theme Description
Using the time limit of producing, storing and consuming of food, the auther aims to state the same destiny of the modern.

Faculty Adviser　　WANG Zhong　LI Zhen
Presentation Media　Installation, models
Exhibits Dimension　1.6m × 30m

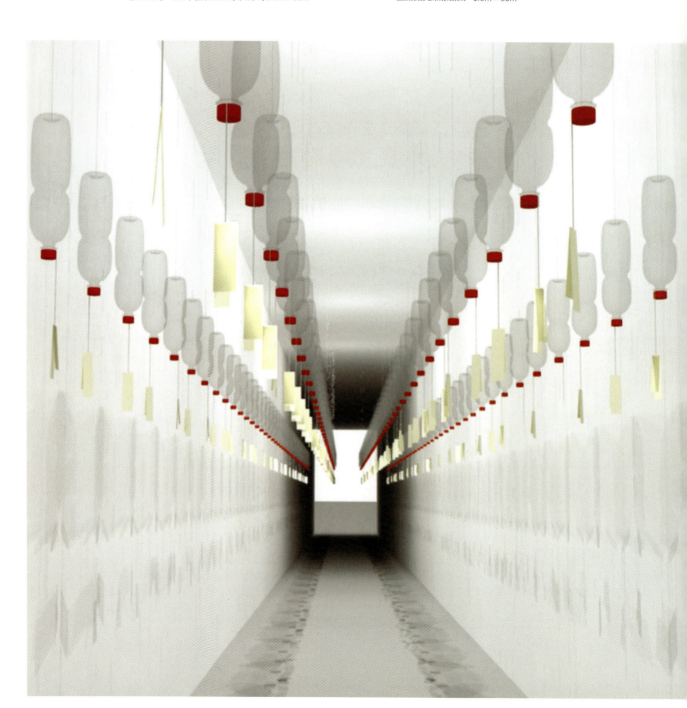

涉江
Wading across the River

作者　张文超

指导教师　马刚
　　　　　冯梦波

表现形式　实验影像

展品尺寸　1440 px × 1080 px

Author　ZhANG Wenchao

Faculty advise　MA Gang
　　　　　　　　FENG Meng Bo

Presentation media　Experemental video

Exhibits dimension　1440 px × 1080 px

快城快蚁
Translocal Ant

作者　珊珊 韩文文 韩冬

作品主题
这个蚁穴的拟人化装置，镜像了人类的生存本质，剖切坚固的、冷漠的、厚重的城市原体，其断面裸露出标准化规格与程式化阵列的单元格和生产机制的疯狂运转，簇拥而来的生存者被编码归类于单元格中，而生存者的行为却无法被操控与预测，其呈现出的自主性、随机性与生动性，解构了城市强烈秩序内质统治下的整齐划一的栅格化表征，从而成就了城市的完整性、偶然性、多样性和各种意想不到甚至不可思议的感性面孔。

指导教师　苏丹

Author　GAO hanshan
　　　　　HAN Wenwen
　　　　　HAN Dong

Work Theme Description
This personified installation of ant cave, an emblem of the living essence of human beings, sectioned the solid、phlegmatic and heavy protomer of the city. However, the behavior of the living can not be controlled and predicted, which leads to the integrity、contingency、diversity of the city and all kinds of unexpected and inconceivable perceptual faces.

Faculty Adviser　SU Dan

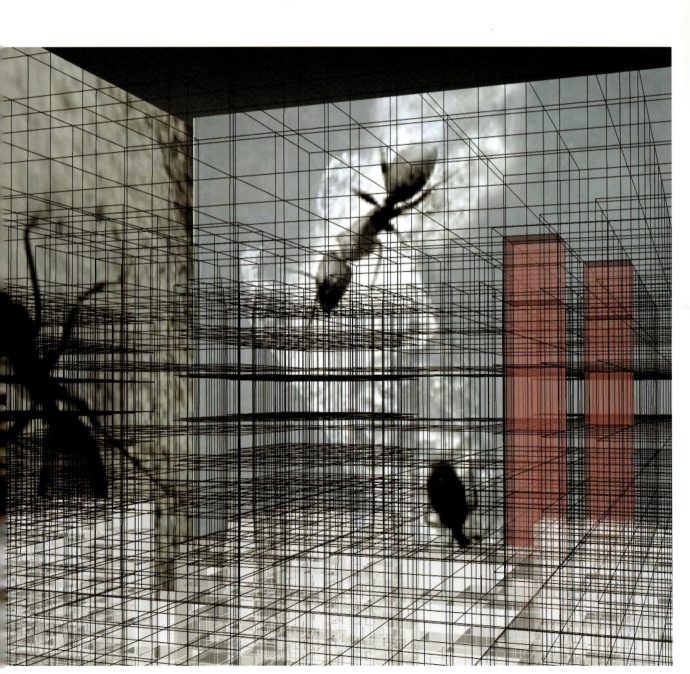

寄存
Depositing

作者　陈炼
进城务工的人蜷缩于他的工作包里，仿佛一切都可以被拎走。

指导教师　张克端
表现形式　玻璃钢着色
展品尺寸　920mm(l) × 410mm(w) × 720mm(h)

Author　CHEN Lian
Work Theme Description
The off-farm worker curled up in his toolbag as if everything coule be carried away.

Faculty Adviser　ZhANG Keduan
Presentation Media　Colored fabric glass
Exhibits Dimension　920mm(l) × 410mm(w) × 720mm(h)

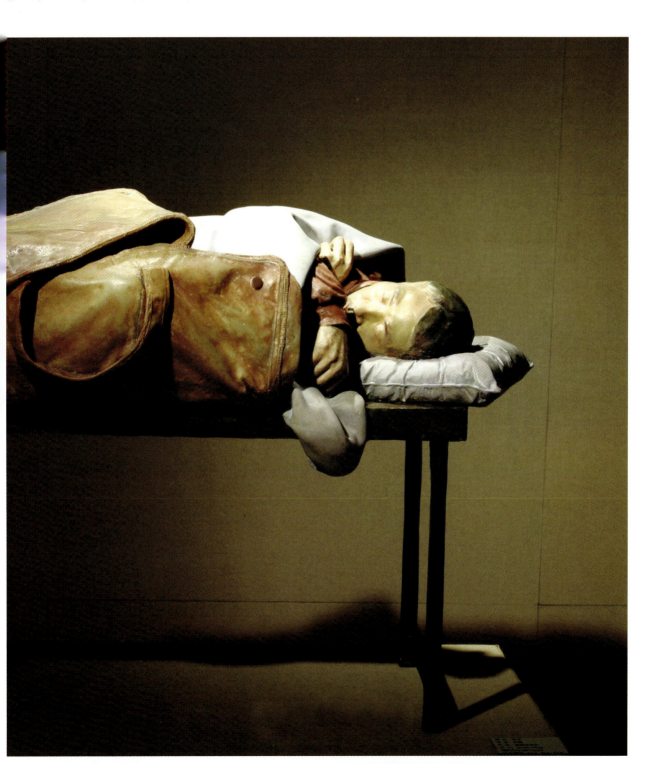

移动的家
The Mobile Home

作者　应歆珣

作品主题
家是一些器物，是家业家产家计，是家具和家私，是家什和家伙是你舍不得扔掉的一切，是你童年用过的一切，是落满灰尘的一切，是超市里不一样的一切。空间，空间中的人，和人所使用的物共同构成了成套的生活形式，这形式向更远处连接着人的信念与选择，人对自己生命的设计。因此人们不厌其烦地从一个城市漂到另一个陌生的城市，带着他们的"家"来到另一个"家"……

指导教师　施慧

表现形式　综合材料雕塑

展品尺寸　1600mm × 1200mm × 600mm
　　　　　2000mm × 1200mm × 600mm

Author　YIN Xinxun

Work Theme Description
Home is waref, family possessions, furniture;is everything you don't want to discard,everything you have ever used in your childhood; everything which is dusty and different from those in the supermarket. And therefore, people spare no pains to move from a city to another city, bring their "home" to another "home"…

Faculty Adviser　SHI Hui

Presentation Media　Sculpture

Exhibits Dimension　1600mm × 1200mm × 600mm
　　　　　　　　　　2000mm × 1200mm × 600mm

一只鸟和他的幻想空间
A bird and it's imagination

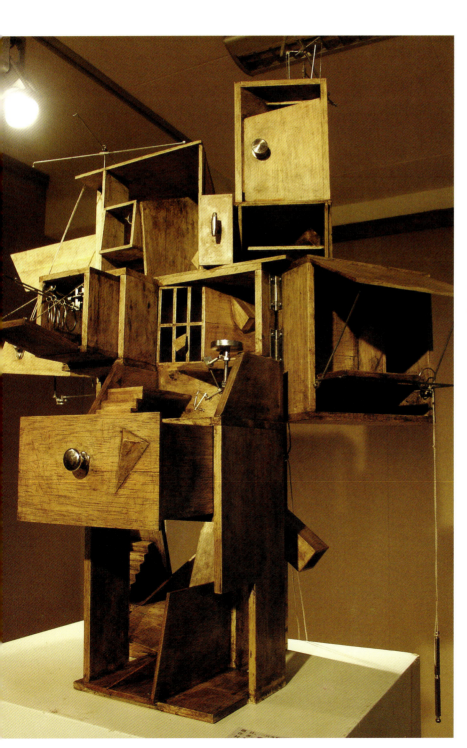

作者　陈政

作品主题
作者试图创造一个另类于现实尺度逻辑下的空间，并在其中糅杂了某种隐秘的内心情绪或者童年遗留的记忆片段。作品呈现出一种矩形构建的方式，其中模拟柜子的打开，抽屉的抽出与延伸，亦旨在打破和混淆正常视觉逻辑，其非同与建筑模型的异类空间，可错乱移动和组合的小部件突出幻想空间这一主题。另一方面，做旧的处理也是在试图营造时间中的空间，记忆中的空间的概念。隐私情绪与童年残影是作品最终的表达意图，犹如一个孩童蜷缩在大人遗忘的书桌底下，拿着铅笔在板面上涂鸦时的宁静。

表现形式　木板材、金属构件、线

Author　CHEN Zheng

Work Theme Description
The auther tried to creat a special space which was totally different from the logic of reality and also mixed some mysterious inward feelings or the memory segment of his childhood into the space.

Presentation Media　木板材、金属构件、线

私人生活
Private Life

作者 李甸

作品主题
五光十色的世界让人不知所措，也许每个人都在寻找着属于自己的那份生活。喧嚣过后，一切归于宁静，"私人生活"残留下的支离破碎的片段，连同都市人的敏感脆弱，深深藏起，就如歌中所写道的：
这是谁的华丽的躯壳
谁让我陌生的微笑着
给我一个密封的铁盒
来装我的一段私人生活
作品通过都市常见的交通工具自行车和纤维弹性材料组合，展现两者互相依存，寄生共存的状态，体现了都市人生活在这高速的社会中，力图保留自我，可又不得不屈服，于是敏感的内心还执著希望留有一点私人的空间，即属于自己的"私人生活"。

指导教师 施慧

表现形式 综合材料雕塑

展品尺寸 私人生活—Ⅰ 500mm×1600mm×1200mm
 私人生活—Ⅱ 500mm×1300mm×1200mm
 私人生活—Ⅲ 500mm×1600mm×1200mm

Author LI Dian

Work Theme Description
Being at a loss in this colorful world, everyone is seeking for his/her private life. After the uproariousness, it cames the tranquility.

Faculty Adviser SHI Hui

Presentation Media Sculpture

Exhibits Dimension Private Life—Ⅰ 500×1600×1200mm
Private Life—Ⅱ 500×1300×1200mm
Private Life—Ⅲ 500×1600×1200mm

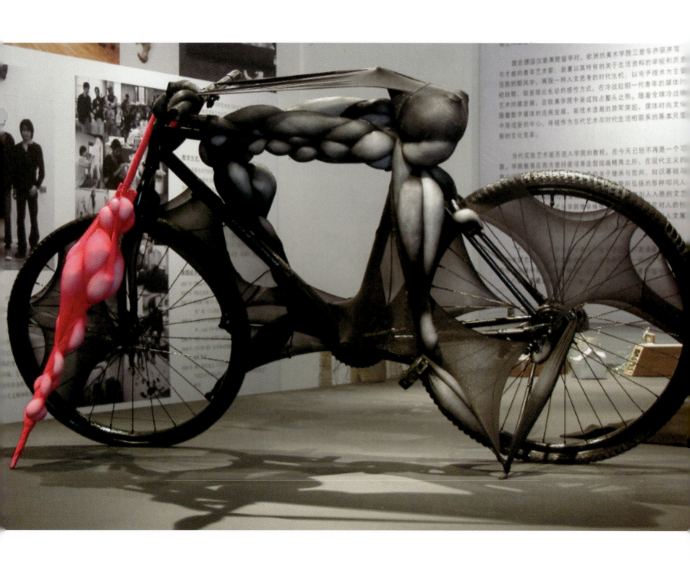

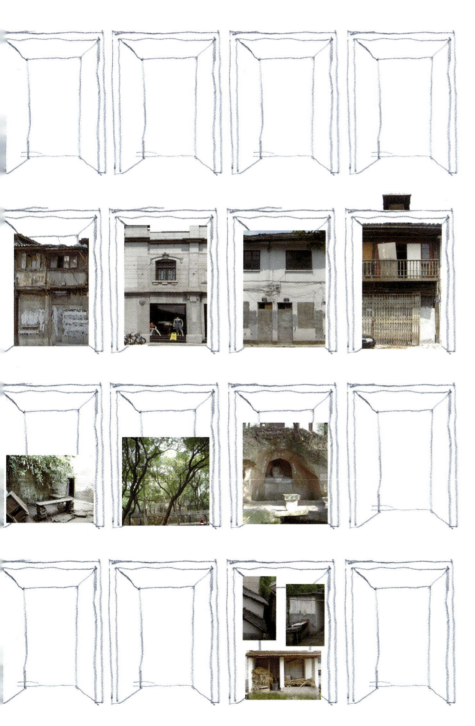

骑楼概念设计
Conceptual Design of the Sotto Portico

作者　陈华平

作品主题
根据中国美术学院《杭州市中山路综合保护和有机更新策划》对现有中山路的城市空间尺度进行修复。中山路中局部道路空间尺度较大的地方，加建骑楼设计。
骑楼作为一个独立的系统，同时又是一个附加建筑，小体量，另外还要考虑到人的活动。设计的概念来源于门房。门房把门的概念进行扩大，门扩大成一个房子。中山路建筑骑楼重要的是和后面的商业用房结合起来。同时门房的设计需要考虑有明确的边界，单纯，可识别性。因此这，找到框形系统，来作为设计的设计出发。然后得出了四种类型,把这四种类型运用到整个中山路的骑楼设计。

表现形式　展板展示

展品尺寸　A0 × 2

Author　CHEN Huaping

Work Theme Description
The concept of the design came from the lodge. It was important to combine the sotto portico with the trade estate behind. At the same time, we should also take the clear boundary and the identifiability of the lodge design into consideration. So we took the frame system as the startpoint of our design. Then we obtained 4 types and used them into the whole design of the sotto portico on the Zhongshan Road.

Presentation Media　Cardboard

Exhibits Dimension　A0 × 2

市井园林
Civilian Garden

作者 董莳 练秀红 徐大路

作品主题
设计采用了市井园林的概念，市井是中山中路现有的生活状态，园林是一种在城市中心区的相对优雅的居住方式。现状的空地成为园林的首选，那将是一个带有市井气息的园林，密集的旧城成为市井最具说明的现场，那将是一个带有园林气质的市井，整个长卷是一个完整的市井园林，有节奏地扮演其特有的城市角色。

指导教师 李凯生

Author DONG Shi
 CHEN Xiuhong
 XU Dalu

Work Theme Description
The design adopted the concept of the "civilian garden". Block is the present living situation and garden is a relatively elegant living style in the center of the city. The present blank becomes the first choice and it will be a garden with the smells of the block. The dense old city, acting as its own typical role, becomes the representative of the block and it will be a block with the smells of the garden.

Faculty Adviser LI Kaisheng

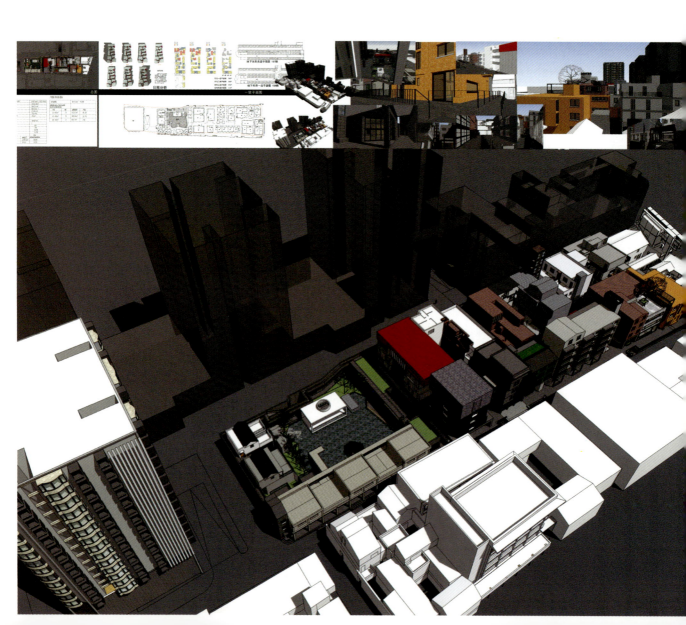

警惕"快餐文化"
To Be on the Alert for 'Fast-food Culture'

黄光辉

Author HUANG Guanghui

主题
警惕"快餐文化"借用快餐本身的载体,把最代表"快餐文化"种现象通过广告语的形式体现出来,警惕人们面对这种现象要"三思而行",并对中国当代都市存在的一些社会现象及人速食文化心理通过再设计的形式进行了警惕、反思,充分表为"社会人"对社会的关注以及作为"设计师"对社会现象的表

Work Theme Description
The work pay attention to the "fast-food culture". representing the fast food culture through advertising slogan, it reminds people to look before leap. this is a reflective and vigilant work about social phenomena of contemporary city and psychology of fast-food culture. It shows people's concern for the society and designer's description for the social phenomena well.

教师 王雪青
形式 装置
尺寸 1500mm × 5000mm

Faculty Adviser WANG Xueqing
Presentation media Installation
Exhibits Dimension 1500mm × 5000mm

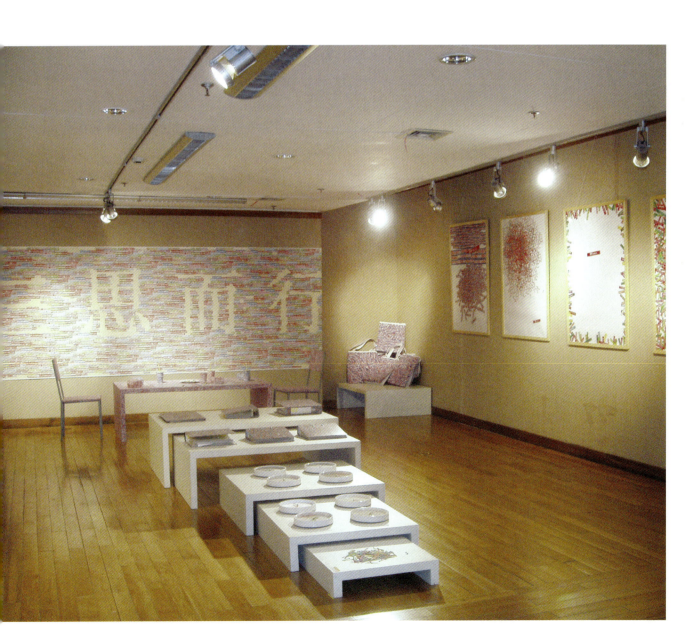

私人空间
Personal Space

作者　杨峻岭

作品主题
代表私人空间的柜子，放在公共的展览空间。人没有接近柜子时，柜子的抽屉处于敞开状态，当人接近柜子时抽屉自动关闭。

指导教师　李凯生

表现形式　装置

展品尺寸　1900mm × 500mm × 400mm

Author YANG Junling

Work Theme Description
The cabinet, a symbol of the personal space, was placed in the the public exhibition space. When nobody comes closely to the cabinet, the drawer was open. The drawer closed if someone comes closely.

Faculty Adviser LI Kaisheng

Presentation Media Installation

Exhibits Dimension 1900mm × 500mm × 400mm

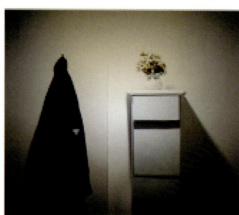

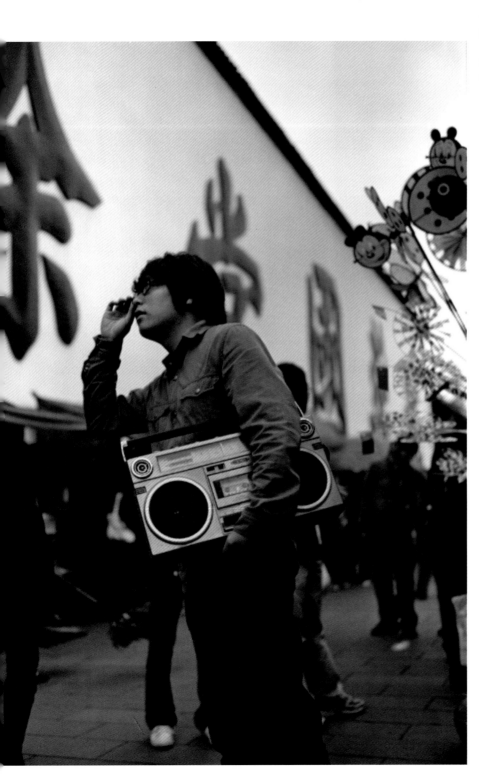

十厘米
10 cm

作者　卢意
指导教师　管怀宾　高世强
表现形式　影像、灯箱（剧照）
展品尺寸　画面16：9

Author　Lu Yi
Faculty Adviser　GUAN Huaibin
　　　　　　　　GAO Shiqiang
Presentation Media　Video and photo
Exhibits Dimension　16：9

火药山水
The Landscape of Gunpowder

作者 陈志远

作品主题
从摄影的本质出发，摄影是记录一段时间内物体被光照射后形成的图像，在这里光是客体，它所起的作用是让物体显现。在火药山水中，火药所发出来的光是非常独特的光源，它在这里扮演着两种角色，一是充当光源照亮假山，让假山显现，是客体；二是这种光本身具有一个形态，充当了被拍摄的对象，是主体。是可控的。这也意味着必须是在黑暗的环境下才能进行的摄影。火药的燃烧过程，也就是光移动的过程。而这个移动的过程以及光的形态通过相机的B门功能，被记录在底片上。这是我们肉眼所不能看到的。

Author CHEN Zhiyuan

Work Theme Description
In this work, we can see the light spurting from the gunpowder is very special. It acts as two roles. One is the object, which acts as the light source to lighten the rockery. The other is the subject, acting as the photographing object.

Presentation media Photograph

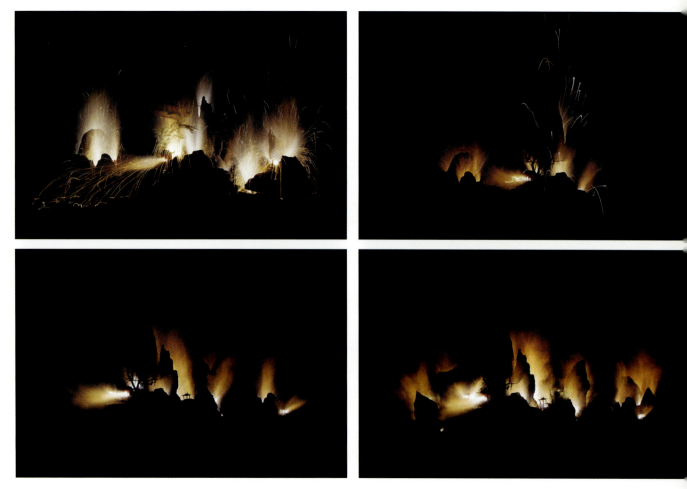

惊蛰
Excited Insects

作者 陈志远

作品主题
春雷乍动，惊醒了蛰伏在土壤中冬眠的动物。这时气温回升较快，渐有春雷萌动。每年公历的3月5日左右为惊蛰。是二十四节气之一。蛰是藏的意思。脚下的泥土被塑造成物，通过从泥土的裂纹中破土而出的光线，使隐藏在物体内部的可能世界得到显现，而物的可能性在瞬间中被剥夺。

表现形式　装置

展品尺寸　4100mm×3100mm×2400mm

Author　Chen Zhiyuan

Work Theme Description
In this work, we can see the light spurting from the gunpowder is very special. It acts as two roles. One is the object, which acts as the light source to lighten the rockery. The other is the subject, acting as the photographing object.

Presentation media　Installation

Exhibits Dimension　4100mm×3100mm×2400mm

天下没有不散的筵席
All Good Thing Come to an End

作者　宋振

作品主题
龙在历史文献的记载中出现的时间极早，而且"舞龙"包含"风调雨顺国泰民安"，原有"祈年"的意思，即人们对未来美好向往的寄托。对于未来的猜测从来就没有停止，也从来就没有定论，所以我认为对于未来我们无法完全用科学的方法推论，只能制造事实影响未来。用自行车舞龙是我对传统舞龙的观念设下的一个机关，也是对传说中祥龙出世的呈现，当舞龙和自行车脱离人的操作在展厅中运动时足以制造一种假像，使观众在梦与非梦之间徘徊，闹钟打破了迷幻让人随着时间思考。

指导教师　杨劲松　邱志杰
表现形式　装置
展品尺寸　1800mm × 600mm × 2300mm

Author　SONG Zhen

Work Theme Description
The dragon dance originally means "the country flourishes and people live in peace" and "praying for the good year". The conjectures about the future never stop and have no final conlusion. Without people's control, the dragon dance and the bicycle are enough to form a false apperance when moving around in the show room that make audience wander between dream and non-dream.

Faculty Adviser　YANG Jinsong　QIU Zhijie
Presentation Media　Installation
Exhibits Dimension　1800mm × 600mm × 2300mm

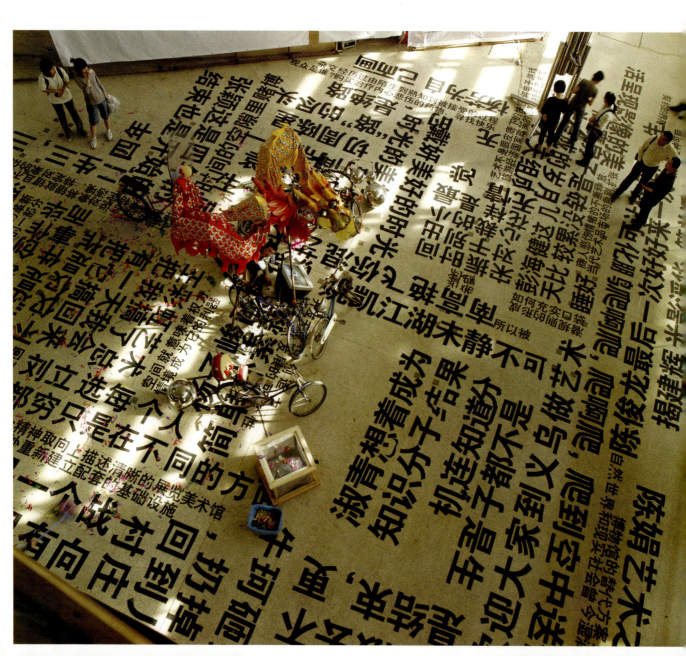

国际旅游者之经典废墟一
国际旅游者之经典废墟二
国际旅游者之经典废墟三
Classical Ruins for International Travellers Ⅰ / Ⅱ / Ⅲ

作者 邵文欢

作品主题
人群、愈来愈多的人群。不同地域、不同种族、不同宗教,蜂拥而至。他们驻足"经典",他们用身体、用感官、用精神去摸触这些圣地。每个人都极尽可能地,通过影像的方式将己与之亲密联系,期望藉此共同"永恒"。然而我在取景器中却看到,他们徜徉在这样的时空经验的依托中,越发显得恍惚、飘忽,甚至百无聊赖,他们与这个被凝固的时空一起,呈现出迷濛一片的面貌。在全球化的潮势中,旅游已成为人们共同追逐的行为,似乎在逃离迅猛节奏,找寻信仰净土。在经典的"景"与"物"之间:我们正感觉越来越接近这些标准的、被尊奉的溯源时,却蓦然发现离它们越来越远。这种游离的关系乃是一种典型的"异化",它带来了恐慌和麻木。"到达"与"悖离"之间竟是位置不确定的彼此接近。这并不是图像强加的概念,因为我们的周遭本身就陷入了一个猜度无尽的漩涡中。即使我们在观看这个记录在此的"真实",也不能说明我们就此贴近这个"真实"。"真实"与"虚拟"的界限缓缓地变得虚妄而诡异。相机存在的意义是被旅游者的身份固化了呢,还是逐渐的消隐去了呢?这种与"神圣"之"景"、传统之"物"的膜拜意义,也因此越来越不确定,而疑窦丛生。我们拥有的是"经典",还是"废墟"?

表现形式 摄影、手工感光涂布及综合艺术手段
展品尺寸 画芯115×172 3张图片

Author SHAO Wenhuan

Work Theme Description
More and more people from different countries, different races and different religions pour in the so called "classic". They try their best to make themselves closely connected with it, expecting to become "eternal" together with the "classic". Is the meaning of the existence of camera be solidified by the traveller's identity or just fading away?
What we own is "classic", or "ruin"?

Presentation Media Photographic emulsion mixed media
Exhibits Dimension 115mm×172mm

理想物
The Ideal

作者　赵婧妍

作品主题
作品以义乌国际商贸城作为创作背景，结合幼儿的经验、创造力、游戏心态等进行艺术创作。整个作品是由装着"理想物品"的发往世界各个城市的箱子；混进儿童理想的招工墙；印着儿童理想和文化博览会贺词的庆典气球以及对各类商铺中的孩子的采访组成。

指导教师　杨劲松　邱志杰
表现形式　装置、录像、摄影
展品尺寸　纸箱190个
　　　　　灯箱1200mm×1400mm×250mm 2个
　　　　　条幅500mm×10000mm 4条
　　　　　招工墙装置2600mm×4000mm 2张

Author　ZHAO Jingyan

Work Theme Description
The work consists of the boxes with the "ideal things" sending to different cities of the world, the recruitment wall mixed with the children's ideal, the celebration balloon printed with the children's ideal and congratulations for the cultural fair and the interview about the children.

Faculty Adviser　YANG Jinsong　QIU Zhijie
Presentation Media　Installation, video, photograph
Exhibits Dimension　纸箱190个
　　　　　灯箱1200mm×1400mm×250mm 两个
　　　　　条幅500mm×10000mm 四条
　　　　　招工墙装置2600mm×4000mm 两张

者 竺斯昀

品主题

者在创作时用了总体艺术工作室一贯采用的调查问卷
实地考察的创作方法，作品《取舍万殊》的原材料全
来自义乌，创作的中心思想也是围绕着义乌这个全球
商品集散中心而定位的，作者把她在义乌小商品城里
集到的物品作为创作材料，更重要的是这些材料并不
真正意义上的义乌商品，而是义乌小商品城里没有任
交换价值的破损的商品。作者把它们按照彩虹的颜色
为红、橙、黄、绿、青、蓝、紫7个颜色，其实是对
些废品进行了另一种意义上的分类，把无用的物品和
虹结合在一起，从而产生了新的暗示，这是不同概念
一次杂交。子的采访组成。

导教师　杨劲松　邱志杰
现形式　摄影装置
品尺寸　900mm×900mm的7张照片，以及一堆垃圾

Author　ZHU Siyun

Work Theme Description
The auther collected the wasted goods in Yiwu and then devided them into 7 colors according to the rainbow. Combing the worthless things with the rainbow gives us a new hint.This is the hybrid of concept.

Faculty Adviser　　YANG Jinsong　QIU Zhijie
Presentation Media　Photography
Exhibits Dimension　900mm × 900mm × 7

取舍万殊
Differences

1:15
1:15 作者 项建恒 叶玲珠

作品主题
本片通过梦境般的艺术语言，描写一个不幸的房间：那里注定什么也不会成功，什么都不会有结果。那种与生俱来的理想，都伴随着那个房间而最终磨灭。

指导教师 常虹
表现形式 影像

Author XIANG Jianheng
YE Lingzhu

Work Theme Description
The film applied the artistic language to describe an unfortunate room:there everything is doomed to fail.The native ideal faded away with this room in the end.

Faculty Adviser CHANG Hong
Presentation Media Image

作者 毛敏南

作品主题

本片主要描述了一段城市人所向往的农村生活的日常生活景象,采用安静、甜美、诙谐的风格,描写了淡淡而深刻的亲情。小女孩在家养着家禽、洗衣服、晒被子、做饭等等,非常的勤劳懂事,老爷爷每天下田锄地,生活非常的单纯,表面上爷爷和小女孩没有什么互动,但通过和谐的生活状态和夏日里的一场雷雨暗示了祖孙浓浓的亲情。

指导教师 黄大为

表现形式 二维动画

Author　MAO Minnan

Work Theme Description
The film portrayed a daily living scene in the countryside. The auther applied the quiet, sweet and humorous style to described gentle and deep familial affection.

Faculty Adviser　　HUANG Dawei
Presentation Media　2D animation

夏日炎炎
Summer Day

小地鼠不知道
Mole Don't Know

作者　李璐

作品主题
一颗种子,在一次意外掉在了地上,它生根发芽长成了个南瓜。一只小地鼠,喜欢拉手风琴。音乐悄悄的从地下的根蔓延到了地上的南瓜里。一只会唱歌的南瓜,吸引了很多小生物,在里面快乐的生活。小地鼠不知道,它的不经意却给了别的小动物一个世界。

指导教师　于瑾
表现形式　二维动画

Author　LI Lu

Work Theme Description
The story is about a lovely mole, a lefted seed, a singing pumpkin and some happy small animals. The mole didn't know that its careless gave other small animals another world.

Faculty Adviser　YU Jin
Presentation Media　2D animation

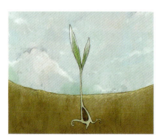
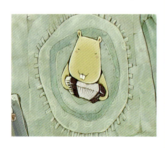
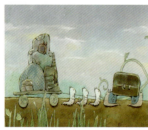
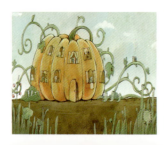
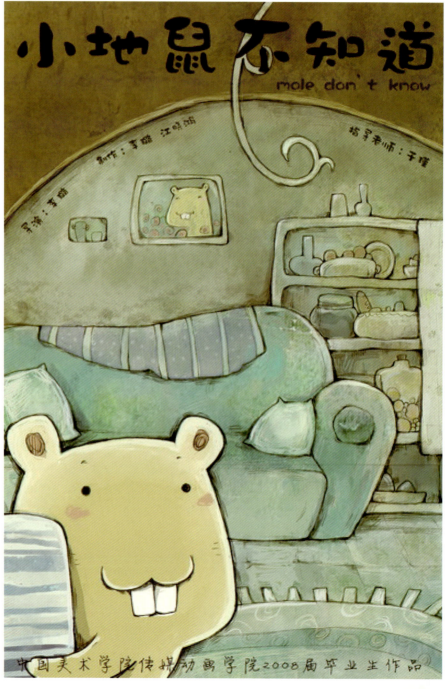

火车开往北京
The Train is Leaving for Beijing

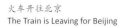

者　张含　陈瑛

Author　ZHANG Han　CHEN Ying

品主题

Work Theme Description

奥运年的中国，大家都在想些什么，做些什么呢？片中以女孩的角度反映一些普通的中国人如何在经历2007年——运的前一年，给我们都带来了些什么呢？小女孩的父母在京为奥运建设工作，小女孩思念父母的情绪都寄托在了从方开往北京的火车上面，对火车的执着，仿佛每一辆火车是开往北京，开往父母所在的地方的。孩子简单天真的思和不着边际的梦，常见的小小亲情，平凡的生活细节……片只是呈现了2007年的一个温暖的小角落发生的不算故事故事。

From the angle of a little girl, the film reflected what the ordinary Chinese people are thinking of and doing in the Olympic year.

Faculty Adviser　QIAO Jingjing

Presentation Media　2D animation

导教师　乔晶晶

现形式　二维动画

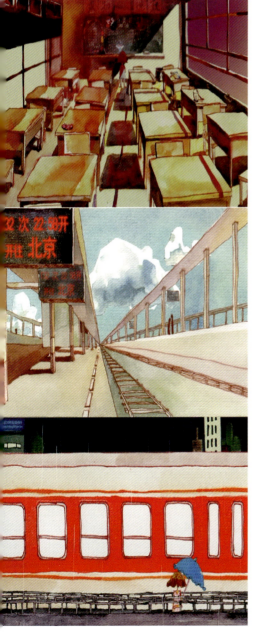

老房子
Home, In Memory

作者 肖裔俊

作品主题
世界飞速发展，旧有的事物不断被新事物取代，但那些美好温暖的回忆不会消失，它们永远珍藏在我们的脑海中，就像童年的回忆，封存在我们曾经生活过的老房子里，留驻我们发生过的每一件事、接触过的每一个人。即使有一天记忆模糊尘封，总会有一个最微小的细节在眼角闪光，让人重拾过去。

指导教师 于瑾
表现形式 二维动画

Author XIAO Yijun

Work Theme Description
The world is developing rapidly. Old things are continuously replaced by the new ones. However the happy and warm memory will never disappear. Like the memory of the childhood, it will be sealed in the old house forever.

Faculty Adviser YU Jin
Presentation Media 2D Animation

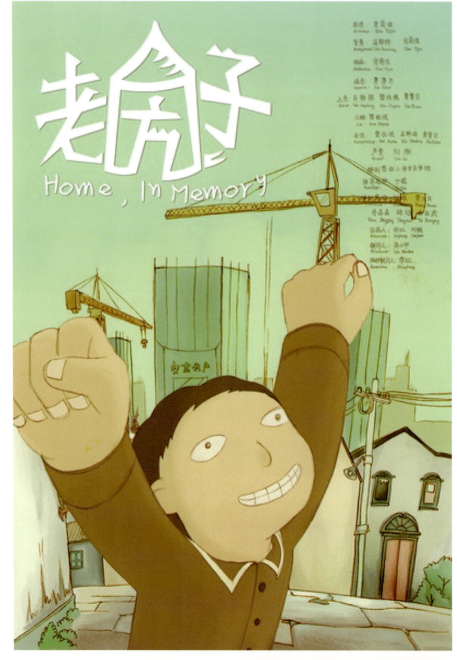

轮回
Samsara

作者 胡加林

作品主题
都市中的人们似乎总是活在一个隐形面具的后面，他们孤独，渴望与其他人交流，却又不敢拿掉自己的面具。他们常常将自己封闭在一个的小小空间里，梦境与现实的界限越来越模糊："我是真的醒着，还是仅是梦见自己醒着？"身体在现实中行走，思想在梦境中漫游。孤独的人最终聚集在一起。把自己的心埋在轨下。路过的火车会带走他们的心。下一站是什么地方？是现实，还是梦境？是依旧孤单，还是会遇见一群伙伴？总之，人总是以各种方式轮回在这个世界。是生活中的轮回，还是轮回中的生活？你永远都弄不清楚，因为你在这个"轮回"当中。

指导教师 李峻 韩晖

表现形式 实拍加三维动画

Author　HU Jialin

Work Theme Description
It seems that people always live behind an adelomorphic mask in the city. They are lonely but dare not take off their masks.Where is the next station? Reality or dream? Samsara in the life or life in the samsara?

Faculty Adviser　LI Jun　HAN Hui
Presentation Media　Videos, 3D Animation

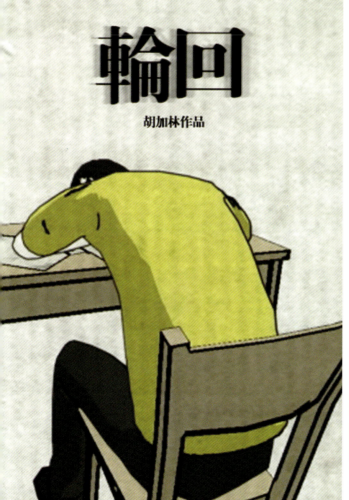

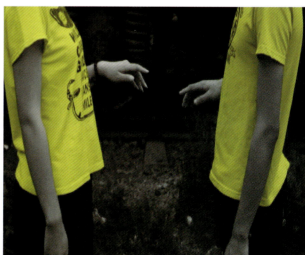

呼吸
Breath

作者　梅健

社会的城市化，是我们不可避免的问题，而我们年轻一代在面对这一问题时，似乎很茫然，特别是我们现在这一代的爱情观，价值观，变的似乎多了一份假象和，少了点老一辈的那些想法。
在当今大量移民的进入和移出，两者都是不同的外乡人，一个外乡人和一个城里人，两个同为同乡人等等，使我们的爱情变的更加复杂和无从。在城市化的城市中，我们的爱情是否还能那么的坚定，这是我们生活在城市中的年轻人面临的感情问题。稳定，真性假爱，金钱的介入，为了快乐……恐怕它不仅仅是对与错那么简单。

指导教师　张培力
表现形式　录像

呼和吸是人类活在世界上的两个必要条件.男人和女人也是如此。
无论是男人还是女人一生中都会遇到好多的选择和抉择,如权利,金钱,性,情人,宗教等等。本片用象征式的手法去表现。（男人直上式的上楼，而在没个楼层都是一种诱惑；而女人是直线式的奔跑，而路过每个101门，同样……）
而最后两着能不能结合一起或有爱情，就在与二者的心是否在一起，去坚守这份爱。这也是当今我们城市中的这一代人对爱情的迷惑，什么是爱情？什么是爱？二人在一起是为了什么？

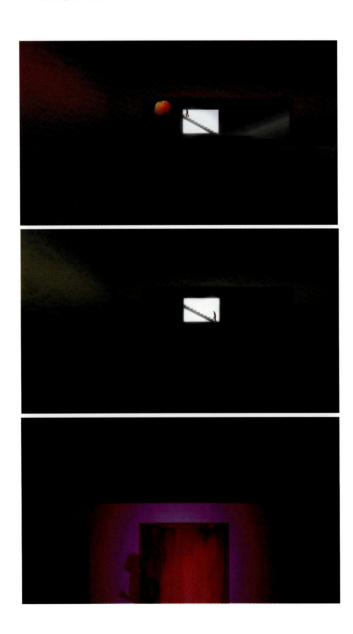

Author MEI Jian

呼吸
Breath

Work Theme Description
Breath is a radical behavior for human to maintain life. The love for man is also another natural conduct to feel the reality of life. But what is love? Why should love come to two persons?

Faculty Adviser ZHANG Peili

Presentation Media Videos

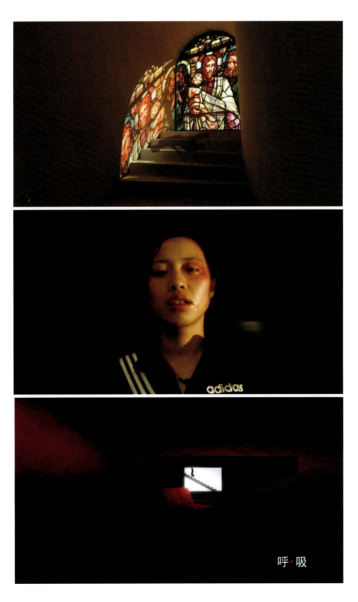

聚
Gather

作者　具娟景　吴诚曦
　　　殷雯婷　王淦
　　　张裕锦　李敏
　　　陈嫣然　苏舒

作品主题
城市是一首聚散诗。无所谓刻意追求，仅仅等待，就能在城市里找到相会的理由，找到快乐的真谛。阴晴圆缺世事难料，就在邂逅的时刻举杯吧！就为我们的相聚而欢愉吧！请珍惜在城市中擦肩而过的每个人。

指导教师　黄英杰
　　　　　周锐
　　　　　陈健
表现形式　展板展示
展品尺寸　600mm × 900mm

Author　JU Juanjin　　WU Chengxi
　　　　　YIN Wenting　WANG Gan
　　　　　ZHANG Yujin　LI Min
　　　　　CHEN Yanran　SU Shu

Work Theme Description
City is a poem of gathering and dispersing. Life is like a boat, so at the moment of encountering, let's propose a toast for our happy gathering!Please cherish everyone who brushed past you in the city.

Faculty Adviser　HUANG Yingjie
　　　　　　　　　ZHOU Rui
　　　　　　　　　CHEN Jian
Presentation Media　Panels
Exhibits Dimension　600mm × 900mm

飞走的留言条
Flying Notes

钱晶

Author QIAN Jing

主题
灵感来自于曾常见于旧上海商场里的"钢丝收银",一个的智慧把柜台与收银台的距离瞬间缩小了。随着时代的，网络聊天代替了旧时人们写字书信，而"钢丝收银"也了历史的舞台。"钢丝收银"的形式有种神秘感，留言后轻轻一滑便飞走到了远方，它有方向，但你却不知道轨多远，也不知道会是谁看到。当一段时间过后，留言条飞了回来，上面写上了回复。在这个城市中，你和陌生一次有了沟通，相近却又遥远。

Work Theme Description
The inspiration of the work came from the "cashing by the steel wire", which was commonly used in the department stores in old Shanghai. The notes fly away and back. Thus, a stranger and you have the first communication in this city, close but distant.

教师 范圣玺 莫娇
形式 装置

Faculty Adviser FAN Shengxi MO Jiao
Presentation Media Installation

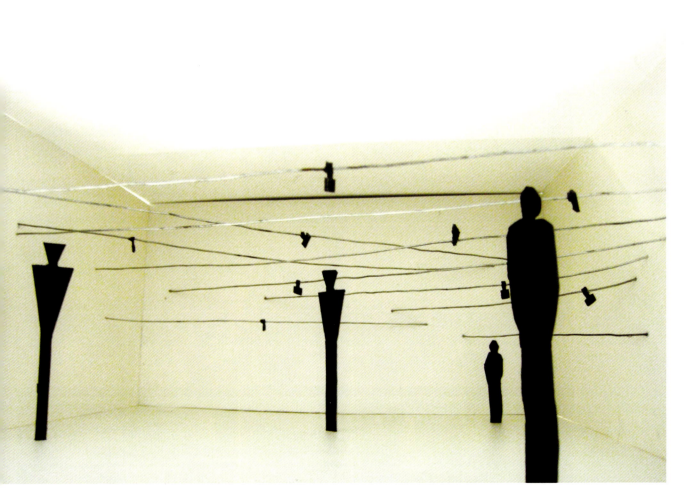

Finger@Shanghai
Finger@Shanghai

作者　张洋　杨文波

作品主题
Finger@Shanghai 以手指动画和现实场景的穿插合成为主线。手指可以说是人身体中可以运动的器官里最灵活的一部分。我们每个人，都随时随地随身带着十根手指，永不离身。人对其所见所闻有时会采取回避或是隐瞒的态度，但是对于手指来说它最清楚、最直接、最下意识地窥测和透露我们的真实想法。在现代这个快速的生活空间中，手指可以表达我们的心声！用手指动画演绎第一次来到上海的外乡人，流连于上海的特色大街小巷，流露出对上海这个大都市的感性认识，或惊美或迷茫、或积极或颓败、或讽刺或搞笑，既抽象又具体，犹如一部卓别林式大都会的幽默喜剧，引人深思。

指导教师　吴洁
表现形式　综合媒介（影像、手指表演）

Author　ZHANG Yang　YANG Wenbo

Work Theme Description
The primary clue of the work combines the finger animation with the real-life scenes. In this fast modern society fingers can express our aspirations artfully.
We use fingers animation to describe a stranger who arrived in Shanghai for the first time. He walked in some unique roads, and reveals his perceptual understanding of this metroplis. It is just like Chaplin's comedy which is humorous but deeply thoughtful.

Faculty Adviser　WU Jie
Presentation Media　Videos, Finger performance

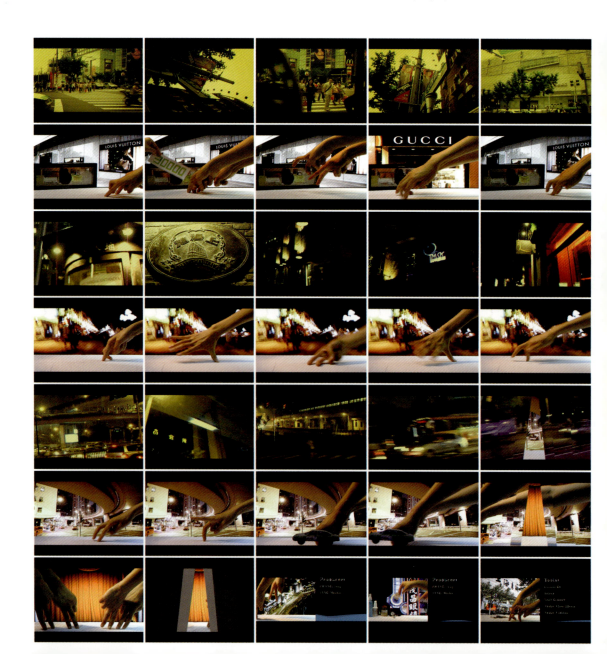

场
Field

作者 朱慧

Author　ZHU Hui

作品主题

他们互不相识，却要在这样一个封闭的环境里，彼此面对。于是，可以作用于他人的场便产生了。它们有着各自的颜色，各自的语言，各自的形态，或交融，或排斥。这仅仅发生在短短的几秒钟几分钟，而之后，我们仍然是彼此没有交集的，来去匆匆的过客。

Work Theme Description

We don't know each other,but we have to face each other in such a sealed space. They have different colors,different languages,and different shapes.They blend or reject to each other.This happens within several seconds or minutes while afterwards,we are still passengers with no intersection.

指导教师　张屹南

Faculty Adviser　ZHANG Yinan

表现形式　录像

Presentation Media　Video

作品尺寸　576px × 720px

Exhibits Dimension　576px × 720px

城市一角
A Corner of the City

作者 孙逢泽

作品主题
城市化范围的扩大，使得更多的人选择从乡村移民聚集到城市中来。城市人的生活节奏规律、紧张、快速、繁忙，使得人与人的关系距离变得疏远陌生，各自生活在自己的世界中，不曾交叉。出于对这样一种城市化状态的思考，作品选择互动的方式来表现这样生存环境中发生的故事。以角色为主要元素，着眼于城市中的一栋普通的居民楼。故事围绕着每个窗口展开，一个窗口即是一个小循环动画故事发生地，每个窗口各代表生存在不同环境不同世界关注着各自生活的城市居民们。作品基于Flash平台，结合Action Script 2.0，受众不再仅是一个观看者，而是更多地是作为一个参与者，以鼠标触动的方式触发一个个循环动画故事。

指导教师 陈健 张屹南
表现形式 Flash交互 鼠标控制
展品尺寸 925px × 380px

Author SUN Fengze

Work Theme Description
Our era sees an unprecedented scale of urban growth, especially in the developing world. Life in city is busy, strained and people are living in their own world.
Taking this situation into consideration, I choose to create an interactive animation which based on Flash and Action Script 2.0. The main scene is an ordinary residential structure where the stories happen. Each window stands for a resident who always focus on his own life.

Faculty Adviser CHEN Jian ZHANG Yinan
Presentation Media Flash Interaction
Exhibits Dimension 925px × 380px

硬币观·上海
Life with Coin @ Shanghai

沈思渊 张思远　　　　　　　　Author　SHEN Siyuan　ZHANG Siyuan

主题　　　　　　　　　　　　　　Work Theme Description
是世界的金融中心，是人口达2000万的国际性大都　Shanghai, the worldwide financial centre, is a cosmopolis which
是2010世博会的主办地。作为当下中国最为常用的　owns almost 20 million people, and also the host of Expo 2010.
单位的一元，在上海又有怎样的绝对价值呢？　　　1 yuan, the coin with the most common use in Shanghai, what
品以flash互动游戏的形式，使参加游戏者探索一元　about its absolute value?
在上海的使用场合和对不同人群的相对价值。　　　This work, in the form of interactive flash games, will help the
　　　　　　　　　　　　　　　　　　　　　　participants explore the relative value of 1 yuan in different
　　　　　　　　　　　　　　　　　　　　　　occasions and to different groups.

教师　吴洁　　　　　　　　　　　Faculty Adviser　WU Jie

形式　互动游戏（动画、影像、图片综合媒介）　　Presentation Media　Interactive games (animation,video,image)

像蝙蝠一样相对尖叫
Relatively Screaming like Bats

作者　张晓钟
　　　李佳砚
　　　谢飞宇
　　　周薇
　　　薛晶
　　　余芳

Author　ZHANG Xiaozhong
　　　　LI Jiayan
　　　　XIE Feiyu
　　　　ZHOU Wei
　　　　XUE Jing
　　　　YU Fang

作品主题
因为都是黑暗，正如都是光明，
他们被抛出边界，抛进云里，
像蝙蝠一样相对尖叫；
没有了欲望，他们无法说出
是非好歹，服从达到完美的时候
是什么将会获胜；
但他们把吹进思想中的说出；
他们被弄得比丑还丑，被解体，
像烘烤前的面团般乏味，
一句话他们就改变了躯体。

Work Theme Description
Because everything is dark, as everything is bright,
they are thrown out of the boundary, thrown into the cloud,
relatively scream like bats;
without desire,they can not speak out
the right and wrong, when obedience reaches the perfect state
what will win;
but they speak out their mind
they are made uglier than ugliness, falling apart,
as tedious as the paste before being roasted,
one word can easily change their body.

表现形式　摄影
展品尺寸　750mm × 1000mm

Presentation media　Photography
Exhibits Dimension　750mm × 1000mm

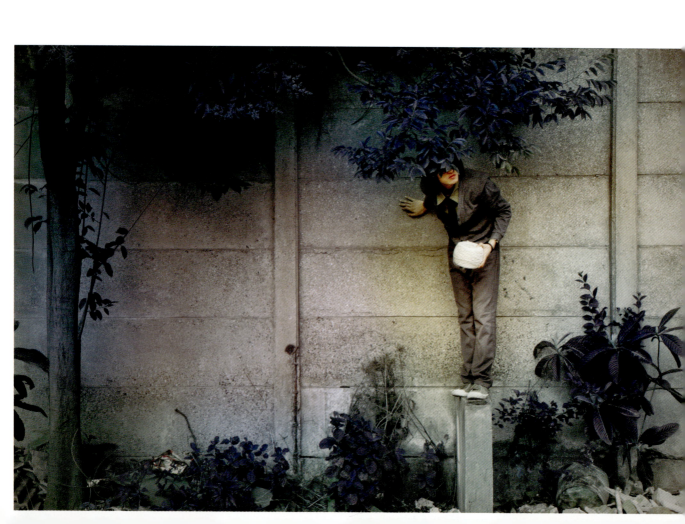

宋可婕

主题

有说生活是个万花筒，而光线在万花筒中不断反射，以另一态反映出生活的方方面面。纷繁复杂的虚像和实像组成的引导着人的思考。6个筒分别盛放了硬币、纽扣、糖果、发票收据以及废易拉罐和瓶盖，分别意指着与人们生活相关的种种问题。在城市急剧膨胀的过程中，这些事物也不断复制增长扩大，正面的、负面的都值得人们深思。

教师 范圣玺 莫娇

形式 装置

Author SONG Kejie

Work Theme Description
Life is a kaleidoscope.
In the 6 containers, there are coins, buttons, candies, pills, receipts and waste pop cans and bottle tops respectively, which reflect people's life in the booming city.

Faculty Adviser FAN Shengxi MO Jiao
Presentation Media Installation

生活万花筒
REFLECT the Blooming City

Repay
Repay

作者 宋忆梦

作品主题
城市生活中的细节往往被忙碌所遮掩，人们在痛恨蚊虫的同时除了使用蚊香却也无计可施。将传统蚊香的形状制作成蚊子的形状（其中蚊香架为蚊子脚），让人们在使用的过程中体会一些小小的情趣；用"蚊子"消失的过程来消灭蚊虫，并将此过程可视化，体现了让蚊子自己用生命付出扰乱城市生活的代价的主题，谓之Repay。

指导教师 范圣玺 莫娇

表现形式 装置

Author SONG Yimeng

Work Theme Description
The auther made the mosquito incense into the shape of mosquito so as to use the process of disappearance of the "mosquitoes" to kill mosquitoes. The work reflects the theme of "repay", which means the mosquitoes pay their lives for disturbing the city life.

Faculty Adviser FAN Shengxi MO Jiao

Presentation Media Installation

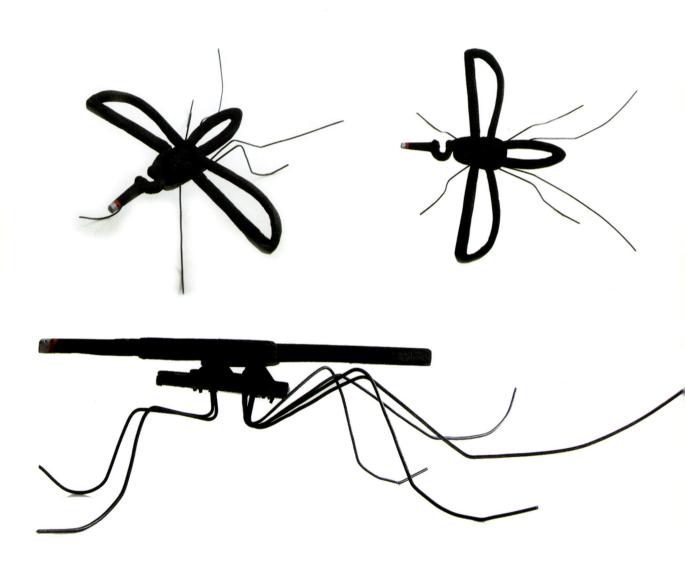

朱灵犀

的发展是在不知不觉中悄然进行的，而生活于城市里的人们
定能捕捉到那些"城市之所以称为城市"的城市感觉。我曾经
学时随着父母从一个水乡古镇搬到上海借读了4年，后来返
却又考入上海的大学。上海外来人口数量庞大，每一个过客
二家园寻觅者都在茫然—寻觅—摸索—倾力中目睹了城市
与发展。这个作品是一本第二形式的课本，文字变成
xxxxxx……"，图片变成了空白框，想作为一个借读于城市的
的笔在课本上的抽象涂鸦，来体现城市过客对城市的理解和
带来影响。而图形体现的是过客-家园的主题以及茫然—寻
摸索—倾力的城市生活者的心境所反映的城市印象。

教师 陈永群

Author ZHU Lingxi

Work Theme Description
The auther came to Shanghai from an ancient water town. As is known to all, Shanghai has a great number of outsiders. Every passer-by has seen the development of the city in the process of being at a loss-seeking-groping-striving

Faculty Adviser CHEN Yongqun

借读·笔尖
Transient·Nib

方言,不丢
Dialect, Never Be Discarded

作者　王宣之

作品主题
城市化建设吸引了越来越多的外乡人涌入城市，人们更多地选择普通话交流，然而这种单一的语言文化环境随即带来方言被遗忘的危机。因此，如今在上海，为了避免下一代遗忘正在被普通话同化的上海方言，上海父母正引导孩子讲上海话，但这种学习更重要的是提供一个充斥着方言文化特色的语言环境的空间或平台，多听多说多用，才能更好的传承方言的语言文化。

指导教师　范圣玺 娄永琪
表现形式　平面及摄影
展品尺寸　A3

Author　WANG Xuanzhi

Work Theme Description
Urbanizational construction attracts more and more outlanders to swarm urban. People generally use mandarin to communicate. Now in Shanghai order to prevent the next generation from forgetting Shanghai dialect whic being assimilated by mandarin. Parents are leading their children to le Shanghai dialect. However what is more important is to provide an langu environment which is full of dialect's cultural characteristics.

Faculty Adviser　FAN Shengxi　LOU Yongqi
Presentation Media　Graphic Design
Exhibits Dimension　A3

城市建设者
City Erectors

作者　殷雯婷

作品主题
烈日下的建筑工人，炼炉边的钢铁工人，马路边的电网工人……他们是城市建设者，让我们的城市日益摩登。大街上人群来来往往，身影匆匆忙忙。其实，每个人都是城市建设者。正是他们在各行各业中默默奉献，一个个生机盎然的城市由此诞生。正是城市建设者，让城市飞速发展。

指导教师　范圣玺 莫娇 黄英杰

表现形式　模型

展品尺寸　400mm × 400mm ×1200mm

Author　YIN Wenting

Work Theme Description
In the street, people come and go hurriedly. Actually, everyone is the city erector. Their dedication give birth to one and another vital cities. It is the city erectors that push forward the development of the city.

Faculty Adviser　FAN Shengxi
　　　　　　　　MO Jiao
　　　　　　　　HUANG Yingjie

Presentation Media　Model

Exhibits Dimension　400mm × 400mm ×1200mm

空间时间—钟
Space and Time – the Clock

作者　白璐

作品主题

由4部分组成，即4个A盘组成，田字形摆放。左上秒钟。左下——分钟。右上——计时器（总是时间未到）。右下——小时。乡下和城市生活不同，勤劳的农民总是按照太阳的起落安排一天的作息，日出而作日落而归。然而在城市，太阳的出现与否都不重要，只有时刻才是标准，在规定时间内完成任务就是真理。时间在继续，秒针在转动，而计时器却总是时间未到。不是计时器出了问题，只是故意想人们放——慢速度，多些时间给自己、给生活、给身边的人……科技的发展给各种信息储存设备带来更大的容量、更高的效率。然而内容越来越多了，我们的时间却越来越少。巨大的储存空间剥夺的是我们思考的空间和享受美好生活的空间……

指导教师　范圣玺

表现形式　装置

Author　BAI Lu

Work Theme Description

Time is continuing and the second hand is turning, but the calculagraph never reach the ending point. There's no problem with the calculagraph. It just aims to make people lower their speed and then leave more time for themselves, life and the people nearby.

Faculty Adviser　FAN Shengxi
Presentation Media　Installation

忙，茫
Busy, Vague

作者 白璐

Author BAI Lu

作品主题
无法想像没有计算机的日子，我们几乎时刻在数字和信息的世界遨游，如果用计算机的语言二进制数字来标注时间，这样是不是熟悉方便多了……

Work Theme Description
Life without computers is hard to imagine. We often forget time when lost in the world filled with data and information. Maybe time should be labelled by computer language. And then, have you find it more convenient to read time?

指导教师 范圣玺

Faculty Adviser FAN Shengxi

二进制	1	10	11	100	101	110	111	1000	1001	1010	1011	1100
十进制	1	2	3	4	5	6	7	8	9	10	11	12
二进制	101	1010	1111	10100	11001	11110	100011	101000	101101	110010	110111	111100
十进制	5	10	15	20	25	30	35	40	45	50	55	60

微观宙
Micro-Universe

作者 陈逸云

作品主题
墨、水、纸张的纹理，它们构成的是微观下的毫厘，亦天然是宏观的世界。人群鸟瞰。从个体、群居，到团队、城市，从个性迥异到拥挤人潮，暗中有一种贯穿始终的秩序，只有鸟瞰才发觉得到。草根宇宙。也许是毛根囊孔，也许是经脉瘀血，也许是野间牧草，也许是山脉地壳。人小城大，城小宇宙大，放大的倍数不同而已。交通轨迹，我在纸张上刻画纹理，墨迹沿着轨道散开，又听话，又妖娆。人们沿着城市的脉络行走，又听话，又妖娆。

Author CHEN Yiyun

Work Theme Description
The 3 sets of paintings are drawn by ink, water and the texture of paper. It's the microscopic under world, and also the macroscopic universe. Overlooking the crowd.
——Special individuals components of the crowded city. Secret order always runs through and only by overlooking can you find out. Grass-roots universe.
——Zoom in and zoom out, you can see hair on your body, people in big city and city in universe. Does a man equal to a universe?Traffic trace.
——Ink spreads along the path of the grains which I carved on the paper, orderly and gracefully. People walking along the city's context, orderly, but beautiful.

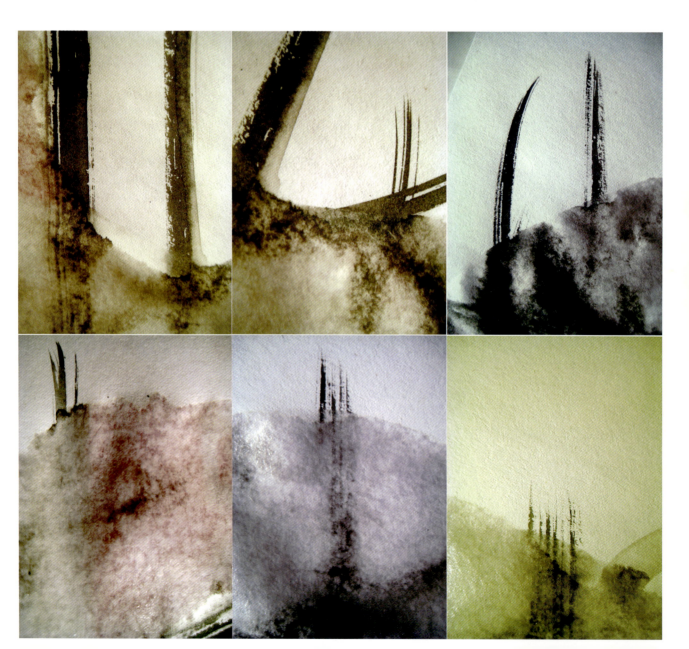

卡带·记忆——卡带日记
A Rolling Diary

作者 郭城

作品主题
卡带日记利用卡带这种与时间和记忆密切联系的物品作为原型,将其原本开口的读卡处作为记录文字的写入口,保留了卡带原有的记录信息的位置和卷动记录的特点,但将其记录信息的形式从无形变为有形,从不可见变为可见,随着记录的增多,纸带厚度的变化将时间的流逝可视化,而写入的记忆也随着卷动埋藏在时间深处。通过概念的创新和形态的改造,使卡带以日记的形式重新回到人们的视线中,而在现今社会快步调的背景下,这种复古的卷动记录方式使人不由自主的放慢脚步,开始了对生活的反思。

指导教师 范圣玺 莫娇

Author GUO Cheng

Work Theme Description
The work is a re-design for the tape which is fading away from our life. Through innovation and reformation, the auther made the tape come back to our life in the form of diary. In this fast –paced society, the old recording mode helps people to lower their step and begin to reflect on their life.

Faculty Adviser FAN Shengxi
MO Jiao

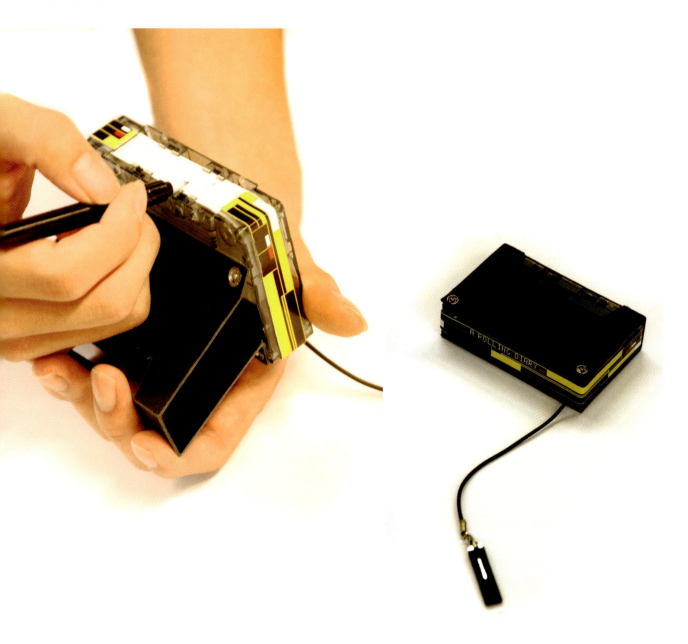

传递
Delivering

作者　陈鑫

作品主题
当今城市人来人往,各种不同身份的人们在城市中擦肩，磨合和重叠。将人群在城市之中空间的流动行走，过客家园的不断变化这一现象通过不同城市间的信件传递这种形式来寄托表达,信件传递不仅传递的是人们之间的信息,也是传递彼此心与心交流的一种方式。表达在不同城市穿梭的人们，无论在哪，城市都是家园这一想法。

指导教师　范圣玺

Author　CHEN Xin

Work Theme Description
Letters not only deliver the messages, but also is a way of heart-to-heart communicaion. The work expresses the idea that even the people are shuttling between different cities, city is always their home wherever they are.

Faculty Adviser　FAN Shengxi

微小城市
The Tiny City

作者 李维伊 陈烨

Author LI Weiyi
　　　　 CHEN Ye

作品主题

2008年的夏天，我们两人决定给我们生活的这个城市带来一点微小而温暖的改变。我们手工制作了许多小衣服，将它们送给为这个城市服务的标识系统上的小人们。就好像我们小时候，做衣服给自己心爱的娃娃。他们将生活在我们制造的全新的场景和故事里面，他们在每个指示牌上交谈、乘凉，或者是日光浴……这些故事来自我们的记忆和幻想。因此我们实际上是把这个城市变成了我们的日记。我们希望当人们在城市的角落里发现这些小小的人和他们的故事，能够觉得有趣和温暖。

Work Theme Description

In the summer of 2008, we decided to bring a tiny but warm change for the city we live in. We made many little clothes by hand, giving them to the little guys in the city identification system. They will live in a brand new scene and story we have created. Actually we have turned the city into our diary. We hope that when people find these little guys and their stories in the corner of the city, they will feel funny and warm.

表现形式　照片及实物

Presentation Media　Photos and actual models

都会·表情
Metropolitan·Expression

作者　钟利雯　顾凤　陈佳　高艺佼

表现形式　装置

Author　ZHONG Liwen
　　　　GU Feng
　　　　CHEN Jia
　　　　GAO Yijiao
Presentation Media　Installationn

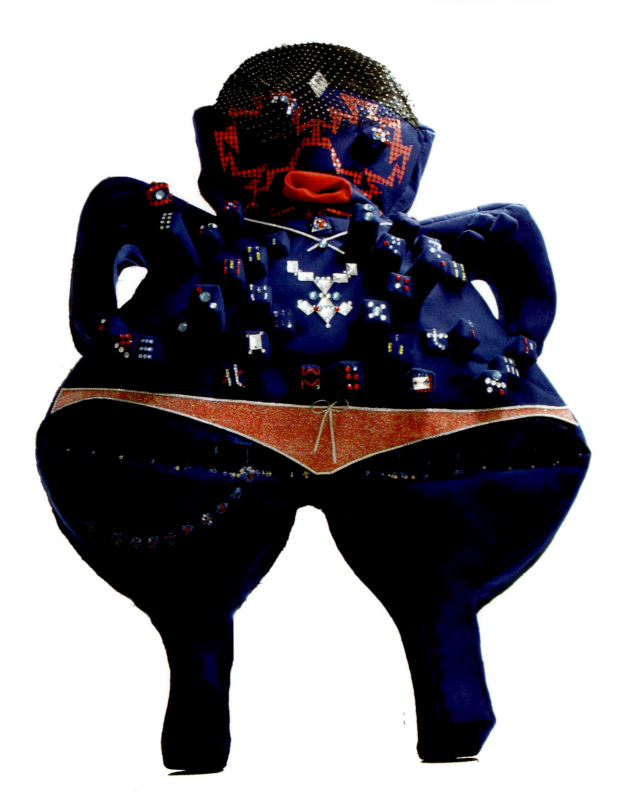

者 洪啸

品主题

界，代表着imagination，代表着I，代表着I love the world，World i》是一部实验动画作品，使用了自己原创的水雾动效果。阐述了两个看似平行的世界——想像和现实之间互矛盾却又割舍不断、互相转化的辨证关系。用一个散文诗的散点叙事方式，讲述了一个独特的故事。

导教师 忻颖

验动画（原创水雾动画）

品尺寸 720px × 576px

Author HONG Xiao

Work Theme Description
In the summer of 2008, we decided to bring a tiny but warm change for the city we live in. We made many little clothes by hand, giving them to the little guys in the city identification system. They will live in a brand new scene and story we have created. Actually we have turned the city into our diary. We hope that when people find these little guys and their stories in the corner of the city, they will feel funny and warm.

Faculty Adviser XIN Ying
Presentation Media Photos and actual model
Exhibits Dimension 720px × 576px

World I
World I

瓶·常人
Bottle·People

作者　范新我　朱玥
　　　沈雨薇　张钦胤
　　　李雅雯　桂佳乐

Author　FAN Xinwo　ZHU Yue
　　　　　SHEN Yuwei　ZHANG Qinyin
　　　　　LI Yawen　GUI Jiale

作品主题
这是一个用现实生活中随处可见的瓶子来构成互动装置。装置中的每一个瓶子代表城市中的一个人。这个装置由5个部分组成。
1 外乡人满怀希望到城市奋斗，随着时间的流逝，激情和梦想最终被城市磨平，从而形成"无性人格"现象。
2 城市中看似毫无联系的人群间存在的隐性交集。
3 人生价值的实现有很大一部分是在一个生活空间中不断寻找、不断碰壁、不断奋斗，并最终找到自归宿的过程。
4 人们不断融入新的人群，并由此引发一系列的连锁反应。
5 城市中不同人群有着不同的梦想。

Work Theme Description
This is a device made by ordinary bottles. Each of them represents for an ordinary person. The device comprises 5 parts.
1. Peasant workers come to the city with dreams but only to see them fade away. The once ambitious immigrants become indifferent as time goes by.
2. Strangers that seems to have no apparent relationships actualluy ralate to each other.
3. The value of one's life is realized in the process of seeking, failing, struggling and finally achieving.
4. People continuously join in new groups; thus a series of chain reactions take place.
5. Different groups have different dreams.

指导教师　黄英杰

Faculty Adviser　HUANG Yingjie

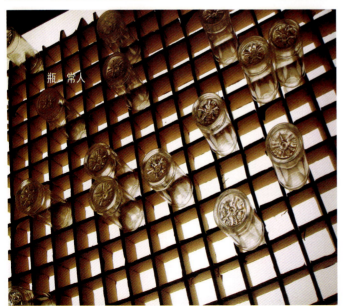

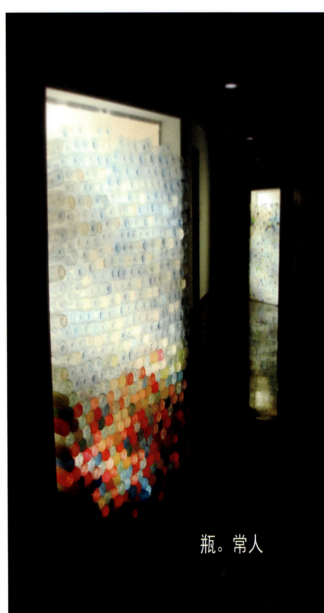

王哲理

主题
线描系列图，以城市中的b类人群为对象，每一张都独立为一个主题。从中心讲，它们的的确都带有一些严肃的表情，而我并不乐于使用同样严肃的表情来陈述们。事实上，每一张画，都是在轻松、安静，并且清醒的环境下完成的，关于、关于普遍的亚健康状态，关于我所在的这个城市的变化与发展，因与果。

Author WANG Zheli

Work Theme Description
This set of sketches focus on the people of Level B, each of which has a topic. From the main point, they're really with some serious expressions, but I am not willing to present them with the same kind of expressions. Actually, each sketch is drawn under a state of relaxing, pleasant, quiet and calm, which is about Level B, about the common sub-healthy states, about changes and development, reasons and results of the city.

Level B
Level B

快城快递
TransLocal Express

作者　黄云东　龙文灏
　　　曹雨晨　邱震宇
　　　俞佳颖　陈韬
　　　戴薪辰　唐任驰
　　　张涛　　庄清峰

作品主题
黑匣子喻示了一种环境。黑匣子的一侧是进入环境五彩缤纷的个体。另一侧是整齐规整的统一出产品。他们被快速打包后运往各处。

Author　HUANG Yundong　LONG Wenhao
　　　　CAO Yuchen　　QIU Zhenyu
　　　　YU Jiaying　　　CHEN Tao
　　　　DAI Xinchen　　TANG Renchi
　　　　ZHANG Tao　　　ZHUANG Qingfeng

Work Theme Description
The black box implies a kind of surrounding, one side of which is the entrance of individuals of different colorful characteristics, while the opposite one comes out well-organized, same-colored products. After packed, they can be sent to everywhere.

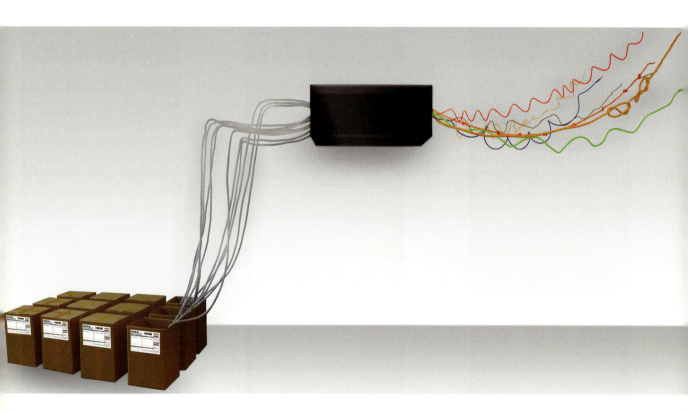

惑·获
Confusion or Harvest

王家琨
田悦倩
陈颖
刘雯妍
陈馨怡
窦颖秋

主题

化，迅速膨胀，在水泥丛林之间穿行，如迷宫般锁形迷心。困惑顿生之间，人，僵化，成为这个城市的一部分。成为与楼宇一般的块面雕塑，在楼宇之间穿梭。地摇摆着钟摆一般的谜题，答案在你的面具之后。

or WANG Jiakun
 TIAN Yueqian
 CHEN Ying
 LIU Wenyan
 CHEN Xinyi
 DOU Yingqiu

& Theme Description

those cloud-capped buildings rising from the plain, cities are now expending in a ling pace. Like children blocked in the labyrinth, we walk in the forest of cement, dazed confused. Numb as we are, we became one undividable part of the structure nsciously. Is it harvest or confusion? Is it the harvest of confusion? The answer lies er your skin.

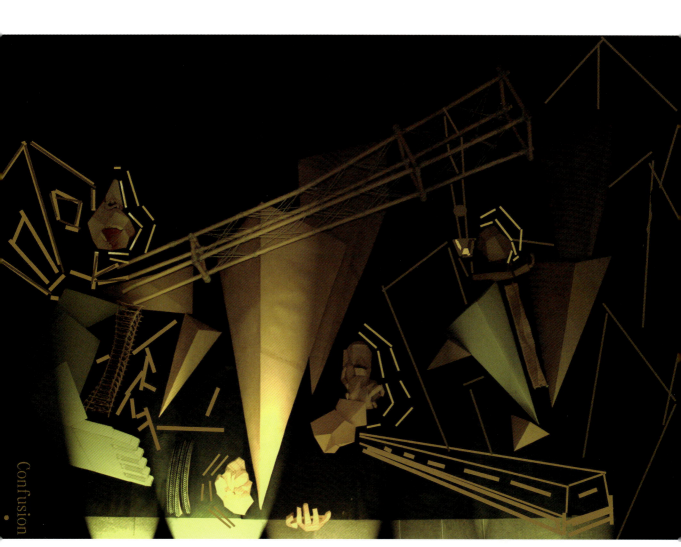

Confusion

边缘城市
Marginal Urban Lliving Space

作者 同济大学建筑与城市规划学院2006级建筑学、2006级历史建筑保护工程专业全体学生

作品主题
13部关于上海"城市边缘生存空间"的联播，是对上海城市特定人群（边缘平民）生存空间、生活形态的真实记录。作品以人性化的方式关注人们尚未注重或习以为常的问题，记录了既陌生又熟悉的现实场景，使观众在观赏的同时窥视到作者的内心世界，一种对生活方式与空间对应关系的解析，一种在这些空间环境中活力元素和存在问题的发现。作品清晰地表达了作者的思维过程和观点以及作者对被边缘化了的城市平民群落的真诚理解。展播空间中的马桶座位既是功能符号，又让观众在特定时空象征物的空间中体验发现的意义。

指导教师 同济大学建筑与城市规划学院设计基础学科组

表现形式 影像放映、9个马桶座位布置

展品尺寸 20㎡封闭暗房间

Author All students from 06 Architecture Department and Historical Architecture Protecting Department, College of Architecture and Urban Planning, Tongji University

Work Theme Description
The show of 13 videos about Shanghai "marginal urban living space" is a true record about the living space and living condition of specific group of people (marginal civilians) in shanghai.These works clearly express the author's thinking process and sincere understanding of the civilians marginalized. The Matong (toilet seat) in the exhibition space is not only a symbol, but also let the audience experience the meaning of discovery in the space of the specific time-space symbol.

Faculty Adviser College of Architecture and Urban Planning, Tongji University
Presentation Media Video, installation
Exhibits Dimension 20㎡ room

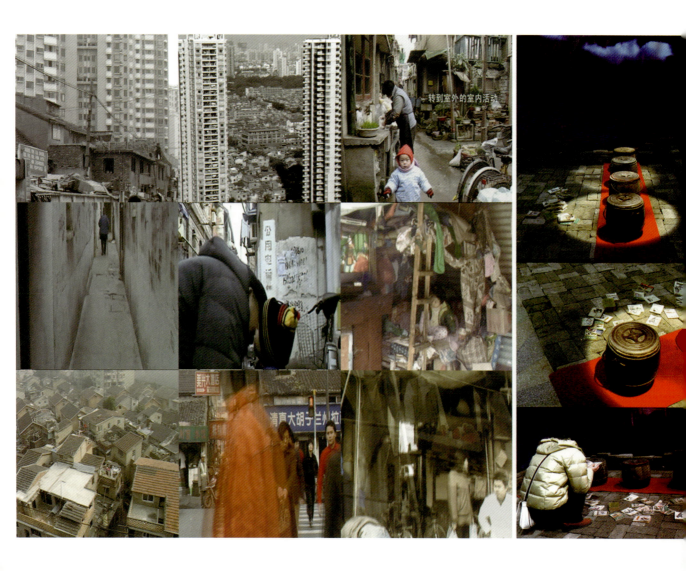

自力更生:
24小时简易自救抗震棚设计建造实验
Self-dependence:
A 24-hours Cardboard Quake-proof Shelter Design and Construction Lab

作者　同济大学建筑与城市规划学院
　　　2006级建筑学3班
　　　2006级建筑学4班
　　　2006级建筑学2班

作品主题
在突如其来的自然灾害面前，我们只是等待救援者的到来，还是迅速自救？"自力更生"是我们的态度，快速是我们的效率，普通的材料是我们的首选，遮风避雨是我们的要求，除此之外别无它求！8小时建造的简易自救抗震棚是我们的成果。本作品是同济大学建筑与城市规划学院"建筑设计基础"的一个课程设计，学生在24小时的建造实验中熟悉材料特点、发现构造特性、设计结构方式、掌握建造方式。8小时建造完成后，学生在自己设计建造的建筑中进行了4小时的公共交流活动，之后还有8小时的居住、寝卧体验，这是对建筑最本质要素的真实理解。

指导教师　同济大学建筑与城市规划学院设计基础学科组

表现形式　室外空间，实体搭建

展品尺寸　5000mm×4000mm×3000mm

Author　Class 3, Class 4 and Class 2 of 06
　　　Architecture Department, College
　　　of Architecture and Urban Planning
　　　Tongji University

Work Theme Description
What should we do when we are in face of a sudden disaster? Are we waiting for rescue or saving ourselves? "Self-dependence" is our attitude. After 8 hours, we complete a shield which is simple but helpful against earthquake. This work is one of the architecture design courses for College of Architecture and Urban Planning(TJU). Students are supposed to acquaint themselves with the characteristics of materials, to find tectonic features, to design the structure, and to grasp the way to build. After that, students will spend 4 hours to communicate with each other in their own space, and later on 8 hours' sleeping inside, which will help them get a true understanding of the essential elements of architecture.

Faculty Adviser　College of Architecture and
　　　Urban Planning,Tongji University

Presentation Media　Actual models

Exhibits Dimension　5000mm×4000mm×3000mm

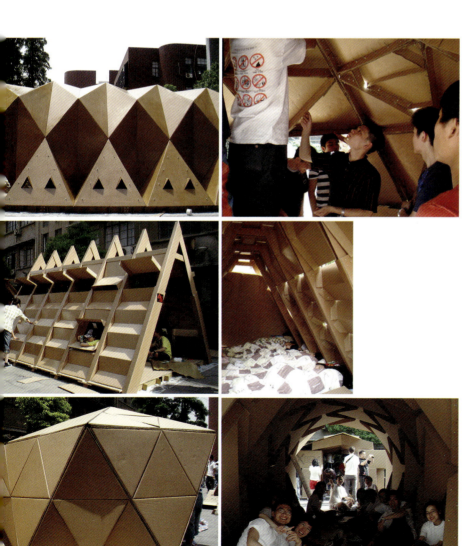

鸟巢
Bird's Nest

作品主题
鸟巢经受不起风吹雨打，地球也经受不起人类的破坏。鸟巢、地球、环境、生命是脆弱的。透过鸟巢设计，表达此脆弱性，呼吁对环境保护及生命的重视。

指导老师 范圣玺 莫娇

Work Theme Description
Nests can not afford the wind and rain, neither can the Earth afford the destruction of mankind. Nests, the Earth, the environment, all are fragile; life is fragile. Through the design of the nest, this expression of vulnerability, we try to call the attention to Environmental Protection, and even more, to the protection of life.

Faculty Adviser FAN Shengxi MO Jiao

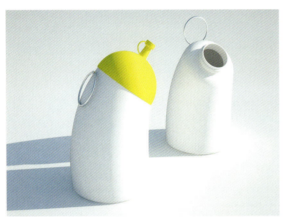

饮料瓶 Drink Bottle

作者 章欣
Author ZHANG Xin

食巢 Edible Nest

作者 虞金红
Author YU Jinhong

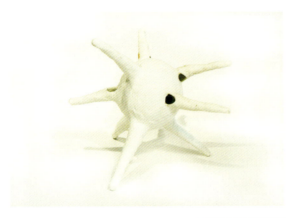

活巢 Living Nest

作者 徐学勤
Author XU Xueqin

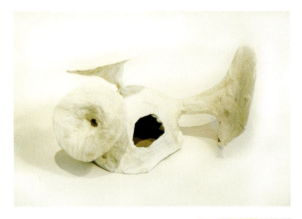

鸣 Twikle

作者 颜丽雯
Author YAN Liwen

鸟巢
Bird's Nest

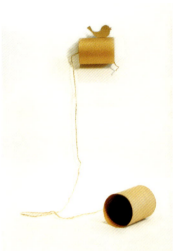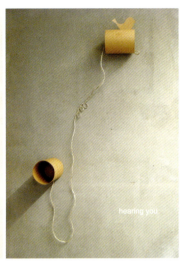

听见你 Hearing You

作者 胡瑾
Author HU Jin

飞不走的气球 Fastened Balloons

作者 钱晶
Author QIAN Jing

消失·巢 Unseen·Nest

作者 汪辰琪
Author WANG Chenqi

鸟巢
Bird's Nest

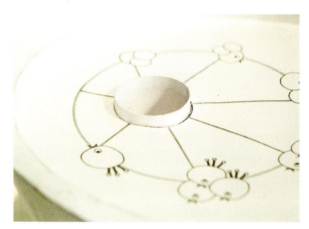

时钟 The Clock

作者 倪辰
Author NI Chen

纸管·巢 Paper Pipes ·Nest

作者 薛白
Author XUE Bai

年轮 Tree Rings

作者 严亦宽
Author YAN Yikuan

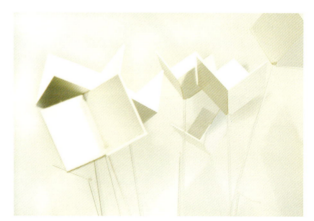

庇荫 Shelter

作者 宋可婕
Author SONG Kejie

鸟巢
Bird's Nest

鸟巢　Hanger

作者　李晓懿
Author　LI Xiaoyi

快快长大　To Grow Up Quickly

作者　林圆圆
Author　LIN Yuanyuan

珑　Liberty

作者　郭城
Author　GUO Cheng

地球·巢　Earth·Nest

作者　高德莎
Author　GAO Desha

斗拱　DouGong Nest

作者　诸爽
Author　ZHU Shuang

破灯，筑巢　Not Lights,but nest

作者　石建亮
Author　SHI Jianliang

第101个城市
The 101st City

作者 钱惠青 贺冰青 赖文莲 顾晨佳 李悦娟 周元

作品主题
100个人的心里，有101个城市。
远眺，是写意的山水；俯瞰，是律动的节奏；窥视，是市井人间。
朦胧的山水之中，以泼墨的方式来表达城中人心里对自然的向往。而象征着理性的灰色航拍图则是我们所生活的城市。跃动的黄色微镜" 是城市中或精彩或矛盾的片断。

Author QIAN Huiqing HE Bingqing LAI Wenlian GU Chenjia LI Yuejuan ZHOU Yuan

Work Theme Description
There is 101 cities in 100 people's hearts.
When seeing in the distance, it's impressionistic landscapes. When overlooking, it's pulsing beat. ¬
When watching stealthily, it's town.
In the form of splashes of ink in the hazy landscapes, we want to express people's aspiration for the nuture.

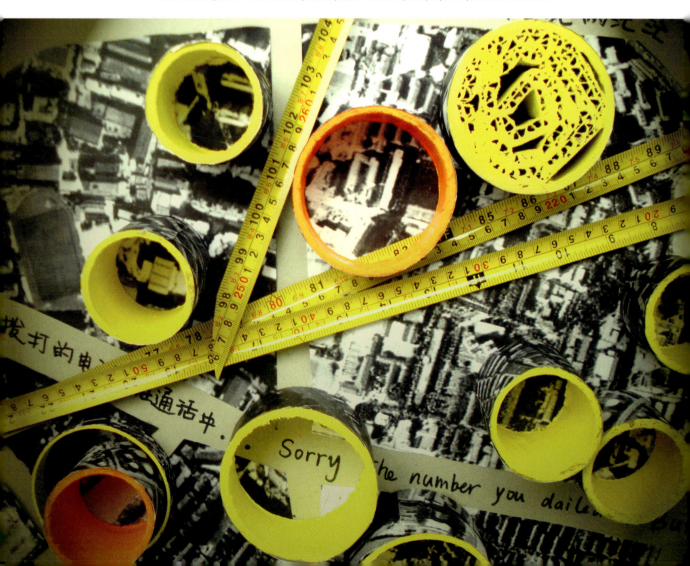

ACtive Context
活络

Author Benny Tam Caroline Wong Linny Sze Chong Tsz Wing Kwok Hoi Ki

Faculty adviser Alvin Yip

Exhibition Coordinator Wong Ling

Work Theme Description
Hong Kong Polytechnic University has continued to partner with industries and innovators in the
Greater China region and around the world. Participating in the International Students' Exhibition of Shanghai Biennale 2008, a petite selection of projects from the WIE (Work-integrated-education) courses are displayed.
Each of the selected projects emerged from, and in one way or another reflected, an "ACtive context"(活络) for design learning. For years the School of Design has proactively lined up real clients with real projects, ranging from commercial products and services, NGOs, NPOs, to government authorities such as the airport, hospital and the police force. A team was tailored every time, mixed with students of different disciplines in the School: Advertising, Visual Communication, Industrial and Product, and Environment and Interior. Along the same direction, the School of Design plays a supporting role for the creative industry of Hong Kong. Recent attempts ofour student teams included a visual libretto for Hong Kong at Shanghai Expo 2010, and the visual identity, catalogue and multimedia design for the Hong Kong exhibition at Venice Biennale 2008.

Chair prototypes for APM Shopping Mall
2007
Student Group Work

Project tutor: Ernesto Spicciolato

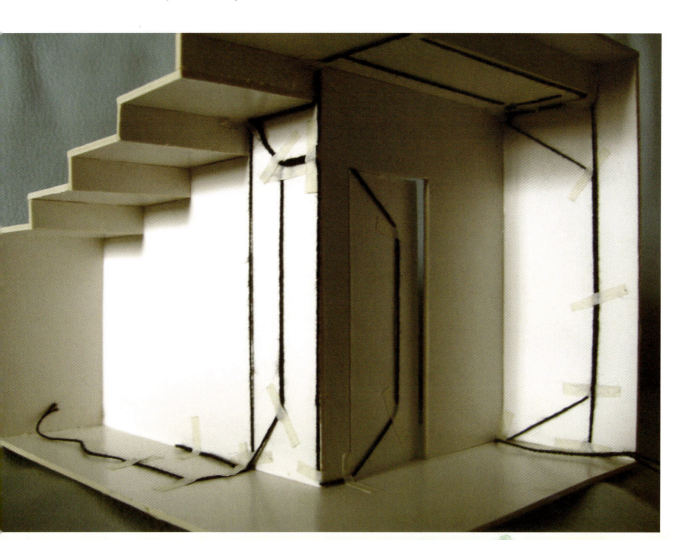

ACtive Context
活络

2007
Student Group Work

Project tutor: Ernesto Spicciolato

School of Design co-op project w/ Sun Hung Kai Real Estate
香港理工大学设计学院 与 新鸿基地产公司 合作项目

APM is a shopping mall in Hong Kong targeted at youth and the young at heart with a desire for a new and exciting place to shop, eat and meet friends. To inject dynamic and interesting elements into the mall, students were asked to design special seating that would stand out from normality.

Six chairs were designed, three of them turned into 1:1 chair prototypes. They are the !WAW! with a smiling face, the Xwaffle inspired by the Cantonese local snacks egg waffle, and the Pop Chair in fluidic form.
Advertising Campaign for SkyPlaza, Hong Kong International Airport

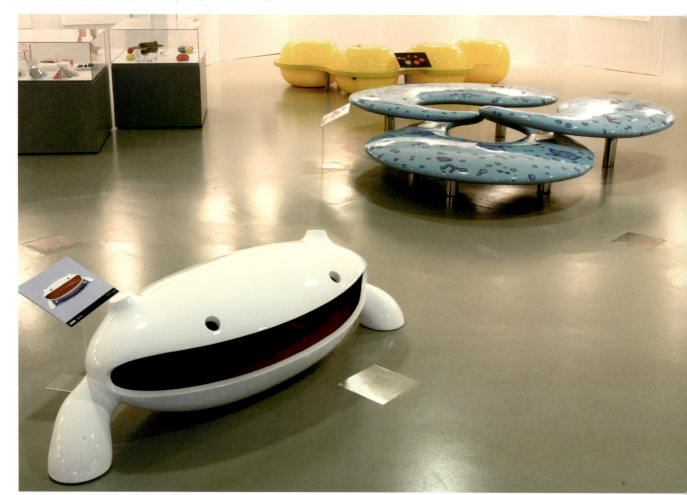

ACtive Context
活络

7
...dent Group Work

...ject tutor: CC Tang

...ool of Design co-op project w/ Hong Kong Airport Authority
...港理工大学设计学院 与 香港机管局 合作项目

...Plaza is an aviation themed shopping Mecca, an integral part of the Hong Kong International Airport. The Airport Authority was looking for creative ideas for an exhibition ...wcase, as well as an advertising campaign to create excitement and generate traffic for its retail combination.

..."Aeroplane chess" comprises core messages of "happiness" and "journey" (由此喜 由此飞). The communication strategy utilized bold colour and the punchy message ...draw people's attention. The tone was dynamic, direct, universal and comprehensible to all kinds of passengers, not only locals. Proposed design applications included ...ctional signs, banners, print advertisements, trolleys, leaflets and souvenirs such as key chain, coaster and mouse pad.

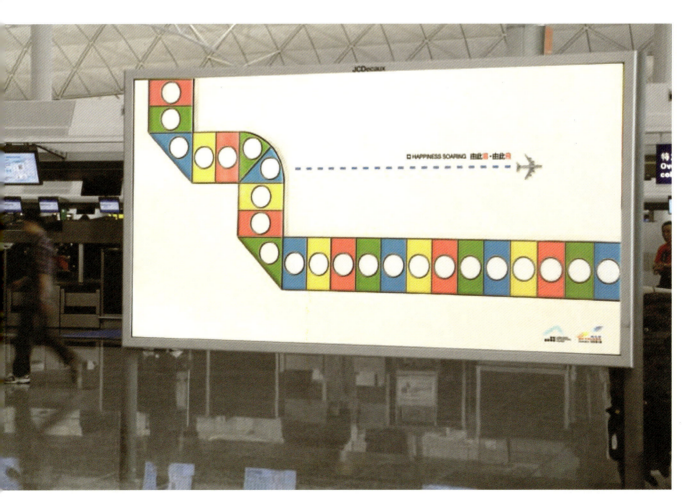

大风景／线的存在状态之嬷嬷人
Great Scenery /
Mama—the Existing State of Line

作者　肖金志

指导教师　张耀来

表现形式　平面剪纸作品／
　　　　　平面剪纸作品或悬挂式旗帜

展品尺寸　1200mm × 900mm × 3

Author　XIAO Jinzhi

Faculty Adviser　ZHANG Yaolai

Presentation Media　Paper cutting

Exhibits Dimension　1200mm × 900mm × 3

精神异托邦／城市——求同存异
Spiritual Eutopia /
City—Seeking Common Ground While Accepting the Existing Differences

肖金志　　　　　　　　　　Author　　XIAO Jinzhi

教师　张耀来　　　　　　　Faculty Adviser　　ZHANG Yaolai

形式　平面剪纸作品+动画影像／　Presentation Media　　Paper cutting
　　　平面剪纸作品或悬挂式旗帜

尺寸　精神异托邦／600mm×600mm×6　Exhibits Dimension　　Spiritual Eutopia/ 600mm × 600mm × 6

有物混成
The Mixture

作者　钟爱

指导教师　刘应武

表现形式　黑白木刻、盲版、综合媒材（不锈钢）

展品尺寸　2420mm × 800mm × 50mm × 2

Author　ZHONG Ai

Faculty Adviser　LIU Yingwu

Presentation Media　Woodcarving

Exhibits Dimension　2420mm × 800mm × 50mm × 2

地球—人
The Earth — Human Beings

作者　许慧晶

Author　XU Huijing

作品主题
每个人都是一个小宇宙，但在现实生活中却成了碎片。社会是这样一种状态，每一个人都像是从身上锯下来的一段肢体，昂然地走来走去，许多怪物，一个手指、一个颈项、一个胃、一个肘弯，但是从来不是一个人。

Work Theme Description
Everyone is a small universe which breaks into fragments in the real life. The society is in such a situation that everyone seems to be some limb sawn from the human body. They stride proudly ahead. They are monsters, a finger, a neck, a stomach, an elbow, but never a man.

表现形式　影像

Presentation Media　Video

展品尺寸　MiniDV 16:9

Exhibits Dimension　MiniDV16:9

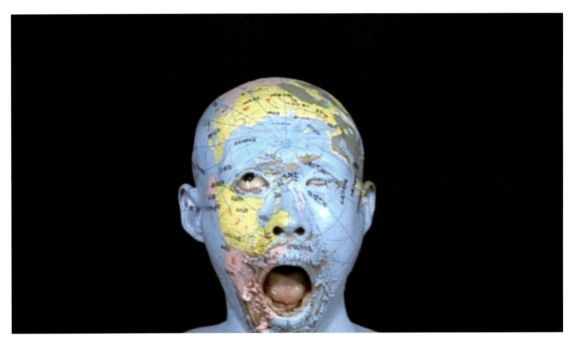

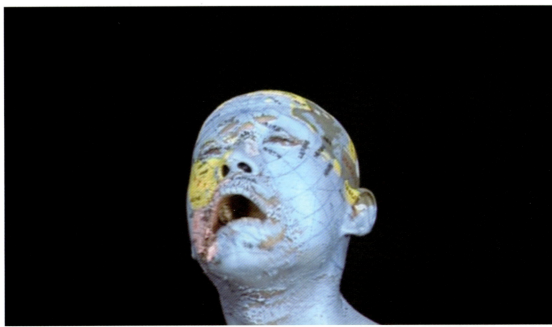

城市的身体
Body of the City

作者 童斌锋	Author TONG Binfeng
作品主题 都会·表情	Work Theme Description Metroplis · expression
指导教师 张宇	Faculty Adviser ZHANG Yu
表现形式 雕塑	Presentation Media Sculpture
展品尺寸 1500mm × 8000mm × 3000mm	Exhibits Dimension 1500mm × 8000mm × 3000mm

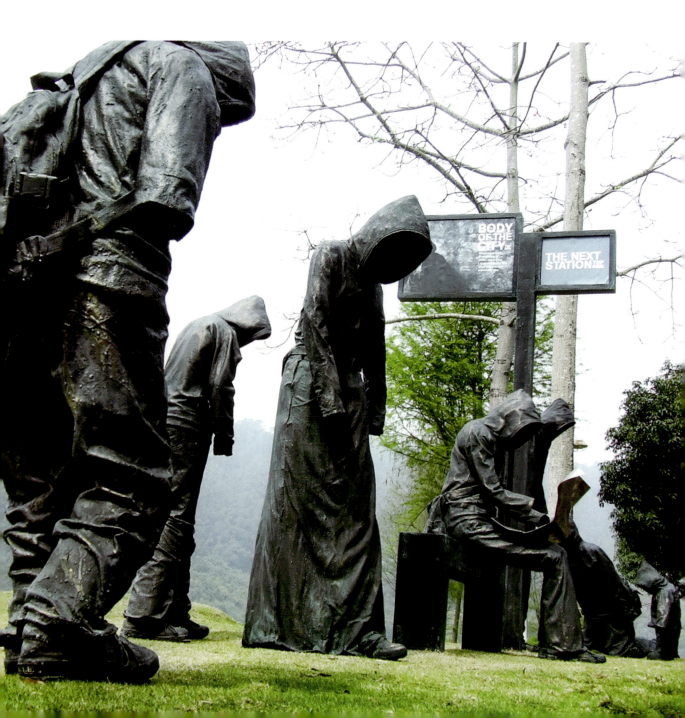

记忆·空间
Memory · Space

作者 陈秋涛　　　　　　*Author*　　CHEN Qiutao

指导教师 吴勇　　　　　　*Faculty Adviser*　　WU Yong

表现形式 书籍、插画　　　*Presentation Media*　　Book and illustration

展品尺寸 220mm×155mm　　*Exhibits Dimension*　　220mm×155mm

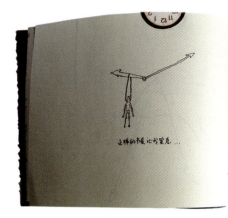

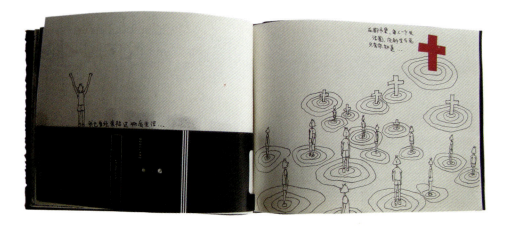

家
Home

作者 张艳
Author ZHANG Yan

指导教师 彭波
Faculty Adviser PENG Bo

表现形式 二维动画
Presentation media 2D animation

展品尺寸 1280px × 720 px
Exhibits Dimension 1280px × 720 px

小地方，大城市
Tiny Place, Big City

Author SHU Yue

Work Theme Description

I looked for "tiny places" in Shanghai, which would stay in contrast with Shanghai's hectic environment. The tiny places are the places where people may stop for a minute to relax, think and talk to themselves. These places may not necessarily mean the geographical location but may also mean the places in people's minds. I designed this book as the final design project in my course. It was divided into two parts, including photographs and the interviews. Through the book, ,I hope the readers can find their own tiny places in the big world.

PFaculty Adviser Marta Kusztra

Presentation Media Photograph, book design

Exhibits Dimension 200mm × 200mm × 25mm

走进农民工，情系留守儿童
Care for the Off-farm Workers and their Children

作者 顾文文

作品主题
多数的外来民工没有能力负担其子女在城市里生活学习的费用，因此有相当数量的孩子在原家乡读书生活。长期分隔两地的生活加重了彼此的思念之情，因此我为外来民工及他们的子女设计了一系列的邮票用以慰藉他们的思念。

指导教师 Marta

表现形式 邮票设计

Author GU Wenwen

Work Theme Description
A large number of the off-farm workers can not afford to pay for the study fee of their children in the city, thus a large number of children have to live in their hometown. I designed a series of stamps to relieve their missing.

Faculty Adviser Marta

Presentation Media Stamp design

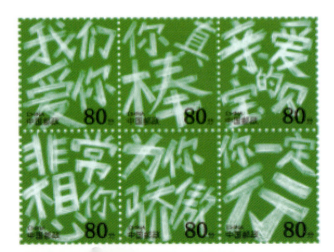

"你来了，我走了"
"You Come, then I Go"

Author WANG Jierui

Work Theme Description
The inspiration of this work came from the illegal advertisement in the city. I tried to use the image combined with the city environment to express my perceptual understanding of the modern city life. It's a living state like metabolism.

Presentation Media Plan chart block on site

记忆·空间 （水墨东阳）
Memory · Space

作者 许旸

作品主题
水墨、古祠、木雕、山水、民俗，带着中国传统艺术的一抹平淡天真，在影片画面中虚实交融，水墨的空灵意境、变化无穷，和木雕恣意舒卷的纹理，唤起了人们的视觉想像和美感。

作品分为3个部分：从东阳古老没落的祠堂文化到东阳即将衰弱的传统雕花工艺，再到与传统建筑一样老去的宗族祭祀的场景。时空转换，记忆的家园一幕幕呈现在我们眼前，多方位反映传统文化本体缺失的现象。社会的转型、文化的变迁，形成了新的生活概念。城市快客在现代文明中流连，却总也割舍不下对故乡的眷恋。一段段乡思在心头绵延，时光滑过指间，已是沧桑百年。

身在世间，蓦然回首，却是断井残垣，诗意栖居亦无边。作品蕴含对生命意义、生存价值的追问，引发人们对传统文化以及现代城市文明的关注，试图唤起人们对传统的追忆和对城市化的积极思考。

指导教师 陶思炎 于向东

表现形式 视频

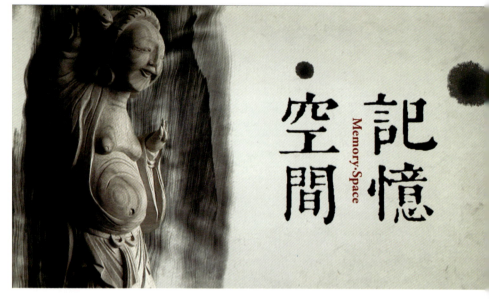

记忆·空间 （水墨东阳）
Memory · Space

Author XU Yang

Work Theme Description
The fast changes of the city leave lots of impacts to our life. The change does not mean only the change of living condition, but also the lose of native culture.

Faculty Adviser　　TAO Siyan　YU Xiangdong
Presentation Media　Videos

你的记忆，我的地图
Your Memory, My Map

作者 高原

作品主题
关于我们城市的地图，所有无法被拍摄到的事物就不能被绘入其中，比如一个人所能见到的事物，脚下的感受，空气的气味，钟声和机车的声响，时间的影响…… 一切个人的记忆。这些感受所能捕捉的事物可能是更加完整的真实。
根据这个想法，我制作了一份有关对城市上海的公共场所记忆的问卷调查（从中选出30份），利用其中收集的信息，用拼贴的方式探索性地设计一张上海的区域地图。

表现形式 装置

展品尺寸 100mm × 150mm× 40mm ×30

Author GAO Yuan

Work Theme Description
I made a survey on the memory of the public places in Shanghai. Using the information I have collected, I try to design a map of Shanghai in the form of collage.

Presentation Media Installation

Exhibits Dimension 100mm×150mm×40mm ×30

大建筑
The Grand Architecture

作者 李鹏飞

作品主题
《大建筑》是一件系列作品，分别由《鸟巢·Bird's Nest》《国家大剧院·Grand Theater》《央视大楼·CCTV Building》构成。以视觉传达的方式，通过平面构成来表达对时代建筑的歌颂。在中国，城市在飞速发展，而这种发展带来的影响无不改变着居住在其中的人们对城市生活的观念和行为思考方式。这种影响带来的冲击最直观的便是城市中大建筑的出现，人们或对其崇拜或思考或剧烈批评，甚至无动于衷。然而它依旧存在，并且发展。
《大建筑》正是从一个平面设计师的角度来关注城市、关心城市、关注建筑、关心建筑，思考"密度"建筑，从而进一步探索城市的生活与文化。

指导教师 蔡顺兴

表现形式 斯特林网布 丝网印刷 立轴

展品尺寸 900mm × 1290mm

Author LI Pengfei

Work Theme Description
From the angle of a graphic designer, the Grand Architecture pays a lot of attention to and care about the city and the architecture so as to explore the life and culture of the city.

Faculty Adviser CAI Shunxing

Presentation Media Posts

Exhibits Dimension 900mm × 1290mm

上海市第八棉纺厂周边地段城市设计
An Industrial Building Re-used Design

作者　上海大学美术学院建筑系部分05级本科生

作品主题
编织———城市节点的复兴
"上棉八厂"地块再利用城市设计

指导老师　莫弘之
表现形式　模型 装置 展板

上海市第八棉纺厂周边地段城市设计
An Industrial Building Re-used Design

Author Architecture Department 05, Fine Arts College, Shanghai University

Work Theme Description
The concept aims to review the old industrial buildings reused in the development of the city in Shanghai. The chontext of the history would play a meaningful role in the changing of our life.

Faculty Adviser MO Hongzhi
Presentation Media Model Installation Exhibition board

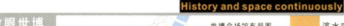

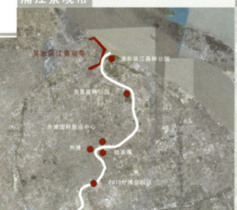
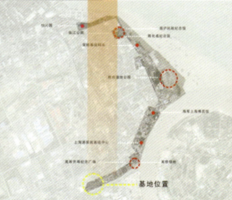

上海市第八棉纺厂周边地段城市设计
An Industrial Building Re-used Design

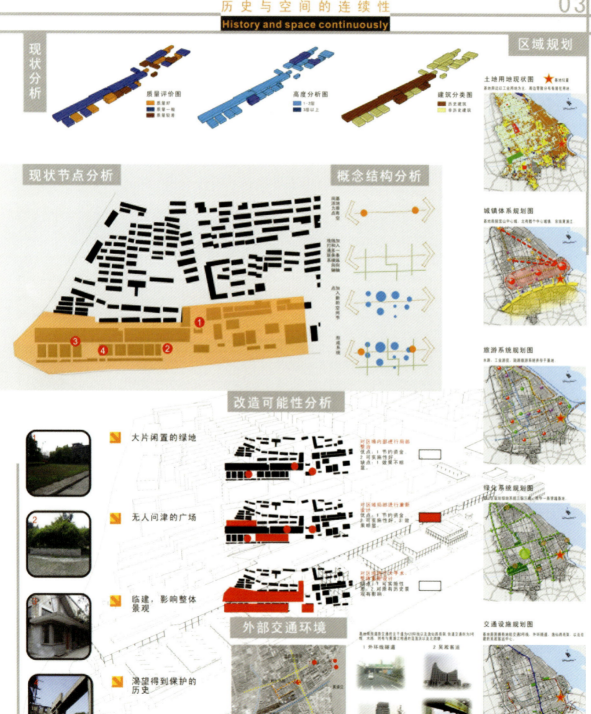

上海市第八棉纺厂周边地段城市设计
An Industrial Building Re-used Design

History and space continuously

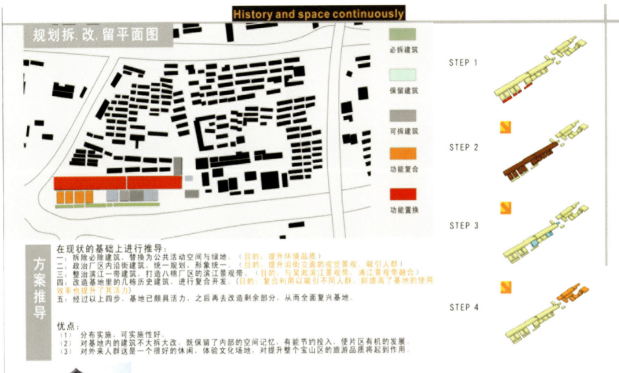

规划拆.改.留平面图

- 必拆建筑
- 保留建筑
- 可拆建筑
- 功能复合
- 功能置换

STEP 1
STEP 2
STEP 3
STEP 4

方案推导

在现状的基础上进行推导：
一：拆除必除建筑，替换为公共活动空间与绿地。（目的：提升环境品质）
二：政治厂区内沿街建筑，统一规划，形象统一。（目的：提升沿街立面的视觉景观，吸引人群）
三：整治滨江一带建筑，打造八棉厂区的滨江景观带。（目的：与吴淞滨江景观带、浦江景观带融合）
四：改造基地里的几栋历史建筑，进行复合开发。（目的：复合利用以吸引不同人群，即提高了基地的使用效率也提升了其活力）
五：经过以上四步，基地已颇具活力，之后再去改造剩余部分，从而全面复兴基地。

优点：
（1）分布实施，可实施性好。
（2）对基地内的建筑不大拆大改，既保留了内部的空间记忆，有能节约投入，使片区有机的发展。
（3）对外来人群这是一个很好的休闲，体验文化场地，对提升整个宝山区的旅游品质将起到作用。

- 保留
- 拆除
- 保留功能 整治实体
- 功能置换 整治实体
- 功能复合 整治实体

开发模式分析

实体 / 功能

保留
拆除

保留功能整治实体
功能置换整治实体
功能复合整治实体

功能使用分析

功能形式	时间段	外来人	本地人
展厅	10：00-16：00		
餐厅	10：00-23：00		
培训	08：00-16：00		
工作室	00：00-24：00		
购物	09：00-22：00		
码头	07：00-17：00		
营销中心	08：00-17：00		
办公	08：00-18：00		
会所	10：00-24：00		

基地内原有的公共开放空间

新增公共开放空间

改造后公共空间人流使用频率

都会·表情
Metropolitan·Expression

作者 俞璐 章惠博

作品主题
信息时代，网络业已成为发达都会城市化的象征。而由网络所派生出的网络表情，已成为网络交际的重要组成。它取代传统意义的五官表情，用抽象的符号具象化个体的喜怒哀乐，生动形象，也使得陌生人之间的交流变得更轻松简单。
本作品由4个人像组成，这四个人像的脸部均为显示器，其中3个显示器不停变换由符号构建成的喜怒哀乐的表情，另一个则为空白，将通过互动装置，由观众来使用符号的模型搭出表情符号，制造出属于观众的独特的视觉表情。

表现形式 多媒体互动装置

展品尺寸 2000mm × 4000mm

Author YU Lu ZHANG Huibo

Work Theme Description
The emoticon deriving from the internet have became an important part of the internet communication. This work is composed of 4 figures whose faces are all display screens. Three of them change emoticon ceaselessly and another one is blank. Through the audience can use the symbol model to make their own visual expression.

Presentation Media Interactive installation

Exhibits Dimension 2000mm × 4000mm

闯荡
Flying and Breaking

作者　侯海莹　梁伟斌　林旭熙

作品主题
装置是一个底部1.4㎡，截面积1㎡，高1.5m的柱状灯饰。主体由铁丝和铁网焊接而成，其中穿插很多纸飞机。在装置的顶部，穿插出铁丝网的铁丝顶端的纸飞机与灯珠组合在一起。我们用这个作品，来记录人在城市二十多岁时一段短暂时光，梦的剪影，飞的轨迹，虽然不一定实现，但至少愚蠢地相信过。

指导教师　陈文静

表现形式　装置（铁丝、纸、灯）

展品尺寸　1000mm × 1000mm × 1500mm

Author　HOU Haiying　LIANG Weibin　LIN Xuxi

Work Theme Description
The installation is a light made of iron, paper planes and bulbs. Many planes are pierced by the irons, a small part of them are flying and breaking , then shine at top of the installation.
As we believe that everyone in the cities all have one time feel the same as we feel now. We all believe we could fly, but maybe it's ture,maybe false. Anyway,we don't care about hurt or not as long as we have experienced.
We use this work to record the short period of time during our young age. The dream of flying and breaking does not necessarily be realized but at least we have ever believed.

Faculty Adviser　CHEN Wenjing

Presentation Media　Installation(iron, paper ,bulbs)

Exhibits Dimension　1000mm × 1000mm × 1500mm

引想
Quote Thinking

作者 张琳 Author ZHANG Lin

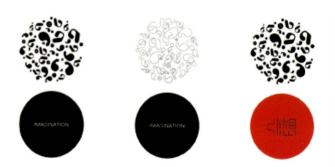

都市传感器——为学生设计的居住单元／
西安钟鼓楼广场时间线
The City Sensor
——The Dwelling Unit Designed for Students／
The Time Line of Xi'an Drum- Tower

作者 田禾

指导教师 任云英

表现形式 图纸

展品尺寸 419mm×147mm

Author TIAN He

Faculty Adviser REN Yunying

Presentation Media Drawing paper

Exhibits Dimension 419mm×147mm

101窗
101 Windows

作者 柳旭 Author LIU Xu

指导教师 罗媚 岳建良 Faculty Adviser LUO Mei YUE Jianliang

表现形式 手绘插画100幅 Presentation Media 100 Illustrations

展品尺寸 180mm×180mm Exhibits Dimension 180mm × 180mm

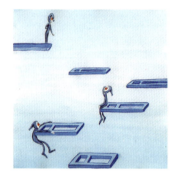 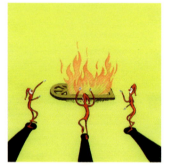 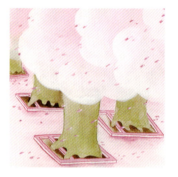 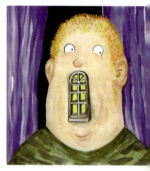
 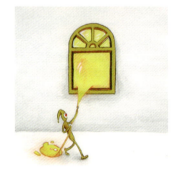 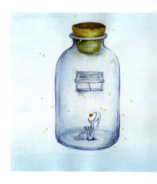

蓝色纸飞机
The Blue Paper Plane

作者　华侨大学团队　　　　　　　　　*Author*　Team of Huaqiao University

脉动
The Pulsating Movement

作者 徐中文

指导教师 郑军
表现形式 纸雕塑
展品尺寸 2000mm × 2000mm

Author XU Zhongwen

Faculty Adviser ZHENG jun
Presentation Media Paper sculpture
Exhibits Dimension 2000mm × 2000mm

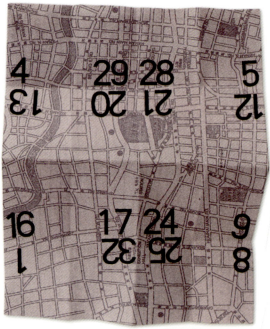

折・台
Destroy the Stage

作者 荆萃 *Author* JING Cui
指导教师 靳庆金 *Faculty Adviser* JIN Qingjin
表现形式 图片 *Presentation Media* Image
作品尺寸 550mm × 550mm，1000mm × 500mm *Exhibits Dimension* 550mm × 550mm，1000mm × 500mm

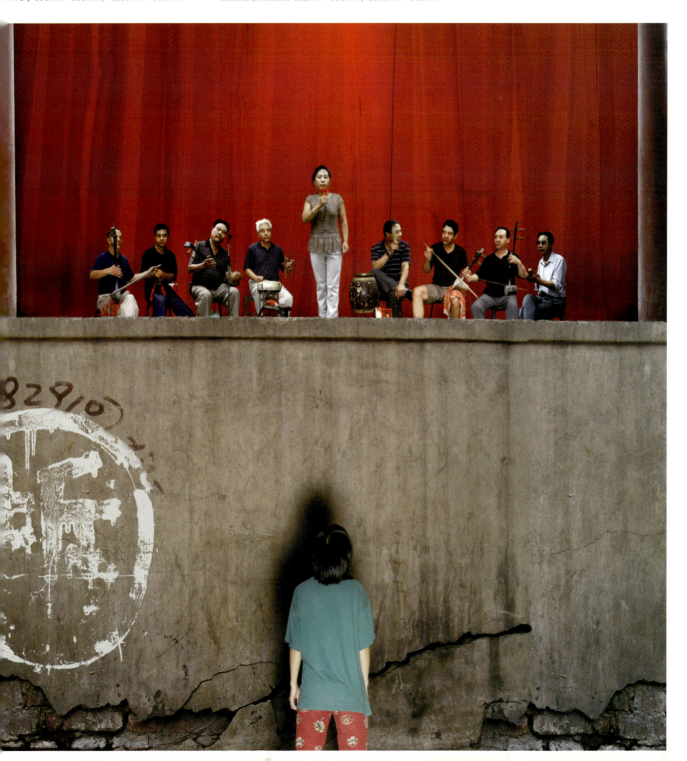

TSUKUMO-GAMI

Design Concept:
Living organisms get born, grow old and finally vanish. Those gradual changes are the beauty of life.
Using wrinkles and rust as a secular distortion applied to the design of the car is expressing the beauty of the aging in the vehicle shape.

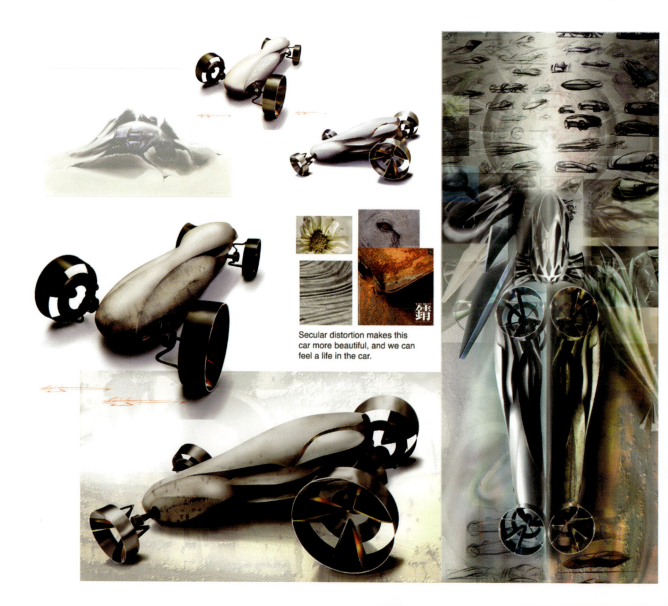

Secular distortion makes this car more beautiful, and we can feel a life in the car.

Research on styling of home PC

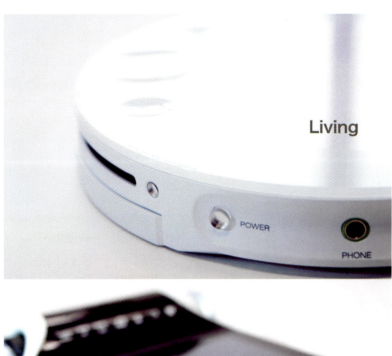
Living

Personal

Mobile

Is the styling secondary, that is, the desktop system and the note type good though it is a product used by various scenes according to each user?

The personal computer of the market is classified into three scenes by three kinds of the theory of making to the amount.

Moreover, specs of a variety of IT equipment other than PC in the home were totaled, and the function and the size were decided.

It proposed "Catati" of new PC to three scenes ;Living, Personal, and Mobile.

PROPOSAL OF A BICYCLE USEING ELASTICITY BEHAVIOR
- Production bicycle made of GFRPP -

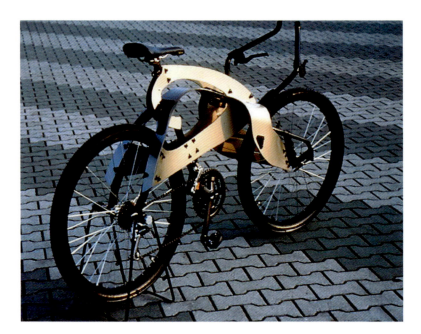

■Continuous approach on elasticity frame

The achievement of creating a bicycle in which the frame had both functions such for the direction and the suspension. It was tried by using the board material GFRPP of low rigidity (fiberglass reinforced polypropylene).

The steering wheel is composed by a rotation mechanism installed in the right and the left part of the front wheel supporter and is places in pairs on the plate and the point. Each plate bends when the body is inclined by the work power at the direction of the axle, and the wheel changes front.

In this laboratory, the bicycle research and the testing were done in a continuous way. When the bamboo frame was used the elastic properties of the material proved to be a good simplification of the structure, this was expected as a result of the integration of the suspension's mechanisms and the steering wheel, and as a result the overall weight could be decreased.

Bamboo frame bicycle panorama

Bamboo frame bicycle panorama

Car getting on three wheels made of bamboo frame scenery

Car panorama of three wheels made of bamboo frame

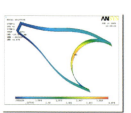

Structure analysis on frame

Making of Tessellation Based on 17 Kinds of Symmetry

A tessellation or tiling of the plane is a collection of plane figures that fills the plane with no overlaps and no gaps and can continue infinitely following the pattern.
The following design shows an original pattern which the motif was the living creatures.

similar dragon pattern

RENTAL VEHICLE in a LARGE-SCALE PARK
- Research of basic function

Design concept :

The aim of this reseach is designing a rental vehicle that will be useful to help to walk in a large-scale park.

The objective of this reseach and analysis, is the design of a multifunctional vehicle that could be used as a stroller, wheelchair, walk helper, etc.

Comfortable to use camera grip

Concept

Usual video camera grip are classified vertical type, lateral type, or transformable type, however, suitable glip angle is not made objectively clear. In this research, I made easy to hold grip angle by ergonomics experimentation with prototypes I experimented. With differents angles of the camera grip concluding with the suitable angle to hold the camera. This resarch is joint research with SANYO, and its results apply to demands of product on the market.

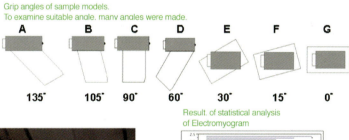

Grip angles of sample models.
To examine suitable angle, many angles were made.

A 135° B 105° C 90° D 60° E 30° F 15° G 0°

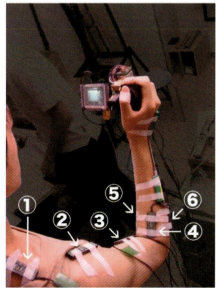

Result. of statistical analysis of Electromyogram

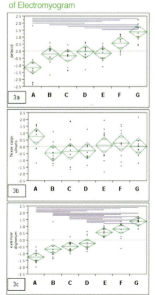

Result. of statistical analysis of Subjectivity evaluation

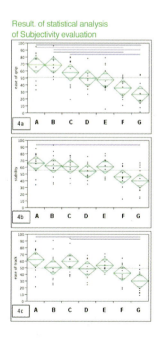

WARABO

Structure of straw:
Straw used in Japanese li[fe] from very old age, here give[s] a look on the relationship [of] straw and Japanese peop[le] at aiming for a sustainable r[e]source circulation system [in] the society.

Dome using warabo

ENGAWA

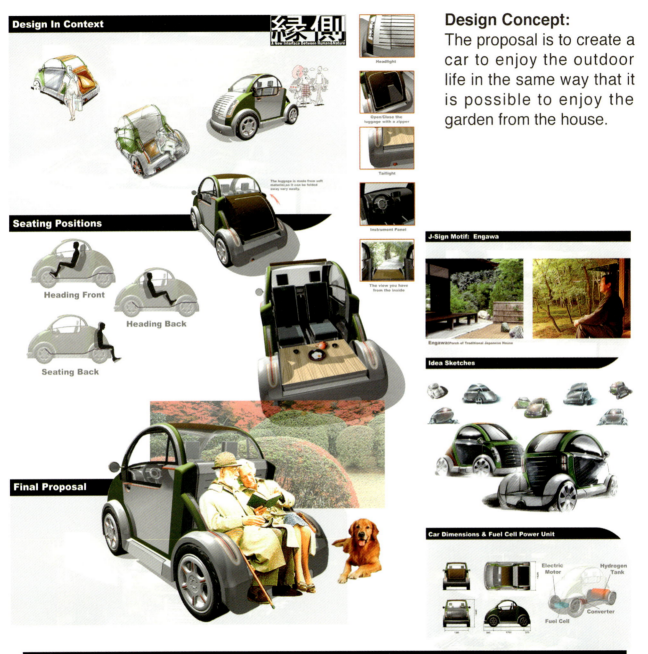

Design In Context

Seating Positions
- Heading Front
- Heading Back
- Seating Back

Final Proposal

Design Concept:
The proposal is to create a car to enjoy the outdoor life in the same way that it is possible to enjoy the garden from the house.

- Headlight
- Open/Close the luggage with a zipper
- Taillight
- Instrument Panel
- The view you have from the inside

J-Sign Motif: Engawa
Engawa: Porch of Traditional Japanese House

Idea Sketches

Car Dimensions & Fuel Cell Power Unit
Electric Motor, Hydrogen Tank, Fuel Cell, Converter

Features

Living space
Living space in Refuge

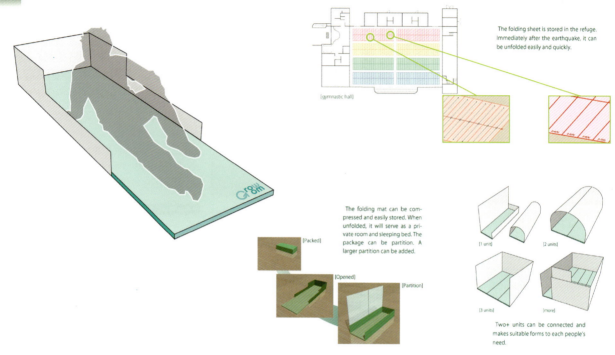

The folding sheet is stored in the refuge. Immediately after the earthquake, it can be unfolded easily and quickly.

The folding mat can be compressed and easily stored. When unfolded, it will serve as a private room and sleeping bed. The package can be partition. A larger partition can be added.

[Packed] [Opened] [Partition]

[1 unit] [2 units] [3 units] [more]

Two+ units can be connected and makes suitable forms to each people's need.

Semi-outdoor space
Using tents in the school refuge

It consists of used as a pair of two units.

joint (front)
joint (side)

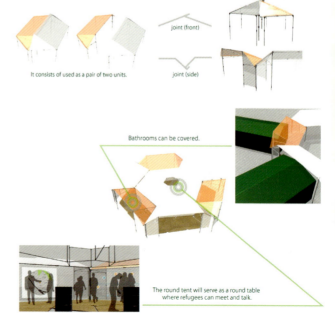

Bathrooms can be covered.

The round tent will serve as a round table where refugees can meet and talk.

Walls, floors, and rooves can be added.

Hold on
抓住

作者　郑俊禧
Author　Hei Cheng

Work Theme Description
My primary concern when making 'Hold On' was the temporal ambiguity of images. The filmstrip is both stillness and movement. Still image when you hold it in your hands, motion picture when it goes through the gate of the projector.
Looking at the frame as the moving picture's fundamental element, this film seeks to unfold the notion of the real and illusory movement. I am motivated by the combination of sound and image, where ideas are expressed in-between meaning and abstraction. This media is projecting a truly international language. It allows me to see with both my eyes and my ears.

Presentation media　Video

Suspended Chaos
悬浮的无序

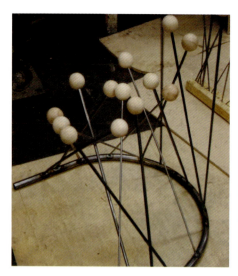
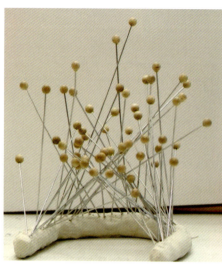

Author Chris Holden

Work Theme Description
Chair for the Memory – Space category

Faculty Adviser Ashley Hall
Presentation Media .pdf file, (physical chair available)
Exhibits Dimension 720mm × 860mm × 860 mm

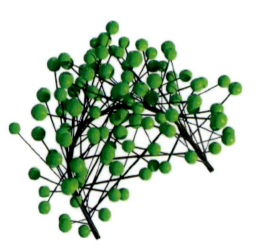

Suspended Chaos
final product: a chair hidden in a cloud of balls

BenD / A Chair that Deforms when not in Use
BenD/ 变形椅

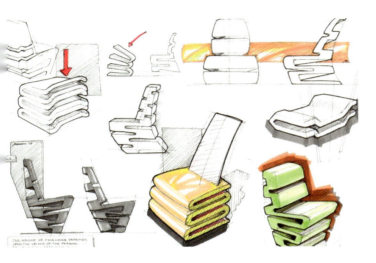

Author Menno Kroezen

Work Theme Description
BenD creates a lively interactive relation between the user and the chair. While the chair is not in use BenD looks unfamiliar with its non horizontal seating surface.
It expresses its desire to be seated by making this invitational gesture to convince the potential user to sit down. Once seated the deformed chair transformed chair transforms into a perfectly comfortable chair.
Because of the bending mechanism BenD assist you to sit down and to get up more easily. These bending qualities are achieved using the qualities of density polystyrene foam. A future production version could be made out of one piece sing expanded polyurethane foam. This would allow the gesture to be even more dramatic. A variant for the outdoors made of recycled rubber is also looked into.

Faculty Adviser Simone Thompson
Presentation Media Model scale 1:1
Exhibits Dimension 40mm(w) × 600mm(d) × 120m(h)

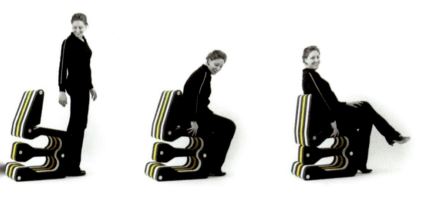

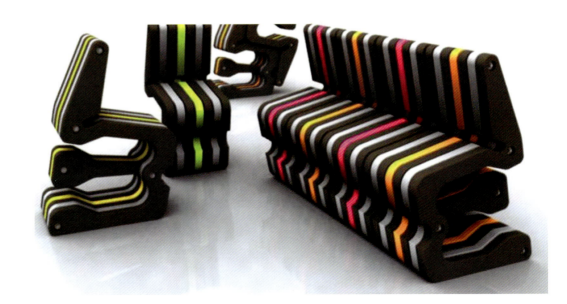

Memory · Space
记忆 · 空间

作者　黄晓路

作品主题
设计分3块场景，一是现实中的空间，二是现实预计交错的空间，三是记忆中的空间。街景素材取自于伦敦和上海两座城市，作者在光影和城市场景的切换中取游玩一次短暂的时间和空间之旅，这种新的视听感受能够让你有无穷回味。也表达了作者身在一向的思乡之情和怀念故土的情怀。

指导教师　Ben Hughes

表现形式　多媒体装置艺术

展品尺寸　600mm × 600mm × 600mm 两个小电视
　　　　　800mm × 800mm × 1100mm 产品模型

Author　HUANG Xiaolu

Work Theme Description
The work was composed of 3 scene. One is the space in the real world, the second is the alternate space of the reality and the prediction, the third is the memory space.

Faculty Adviser　Ben Hughes

Presentation Media　Multi-media installation

Exhibits Dimension
　　Two televisions　600mm × 600mm × 600mm
　　　　　　models　800mm × 800mm × 1100mm

Missing Mind
缺失的思想

Author Yan Gu

Work Theme Description
I have created an enclosed environment full of my illustrations. These illustrations show the marvellous world of my dreams, and I want to welcome the audience into my dream.
I did performance in this space; I performed my dream and while I was performing the pattern made me forget myself and I became part of the room; I dreamt myself into a butterfly - or had a butterfly dreamt to become me?
I want to use these performances to show confusion and puzzling thoughts; I want to create a state of mind that one cannot escape, and cannot control the fluctuation between the real and surreal of our lives. I think that we feel these feelings in our conscious city lives, and that's what I want to express in this visual language.

Faculty Adviser	Andrew kulman
Presentation Media	Photography and video
Exhibits Dimension	Photography (2000mm × 1330mm) × 2
	Video (full screen 2000mm × 1330mm)

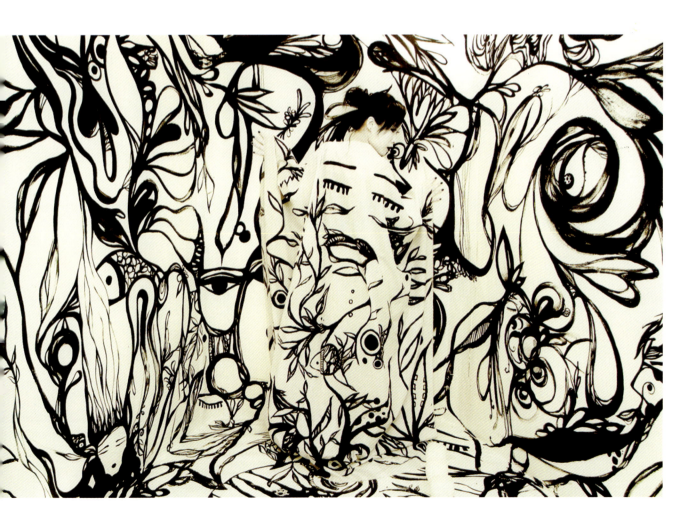

Human Connectedness
人的连通性

Author Alison Thomson

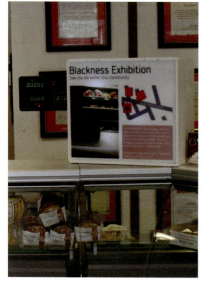

Work Theme Description
Human Connectedness is an exploration of human relationships in today's society. By developing a design framework this investigation explores the unique characteristics of a local community in an urban environment in Dundee, Scotland, UK. The project has uncovered an underbelly community, which has a beautiful network of human connections existing within the area. Techniques were adapted to tailor this project, beginning with the smaller issues, leading to larger complicated problems.
The conclusion of this project is 'Blackness Road Exhibition', which illuminates the beauty of the community in Dundee. The exhibition exposes the story of Human Connectedness through communicating rationale, process and outcomes. Through the exhibition format of light boxes and peepholes, it encourages you to tune into what is around you and witness human connectedness for yourself. The exhibitions location is site specific, leading you to the actual participants of the project within the public space. These findings are not only relevant to the community on Blackness Road, but are also transferable wherever people interact.

Faculty Adviser Jeanette Paul
Presentation Media 6 light boxes that are the touch points of the project. They allow direct physical interaction with the project, as they can be switched off and on.
1 video with sound, that provides footage of the project in action.
Exhibits Dimension Light boxes measure 340mm × 300mm × 200mm

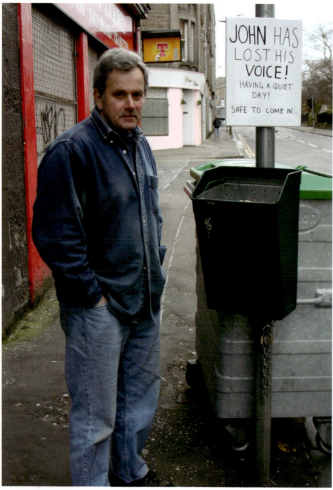
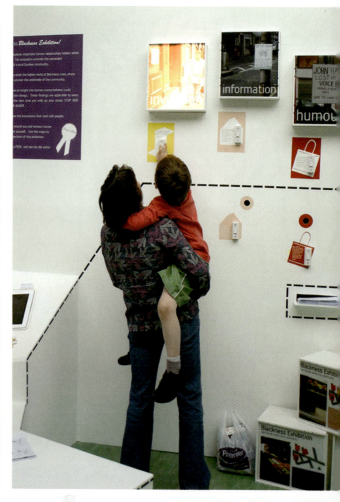

Portrayal of Urban Violence through Textiles
织物都市暴力写照

Author Andrew Stevenson

Work Theme Description
My work examines the social and political history of my country, Northern Ireland. The political and cultural disruption is a direct result of terrorist violence over the last century. I am interested in how the city environment, has been scarred by the violent activity of the past. My research also examines how the media's portrayal has glamorized the ferocious and sadistic aspects of a culture to seem fashionable, which speaks about the decadent state of the world today.
My woven panels reflect the city environment, which I have further screen-printed on top to convey the problems of urbanization and terrorist violence. With these I have produced a selection of mixed-media drawings to show my inspiration and development thinking for design in cloth. Ultimately I have created fabric, which portrays these issues and at first sight seems glamorous and rich but with further analysis is actually exposing political or cultural differences in our urban environment.

Presentation Media Activity in N.Ireland. Woven panels and mono print drawing.

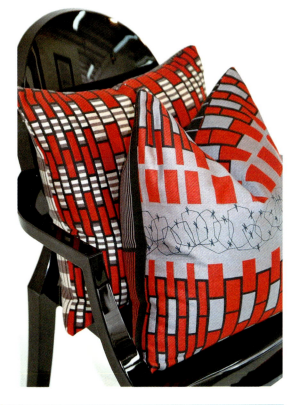

FUSE20: Space
FUSE20: 空间

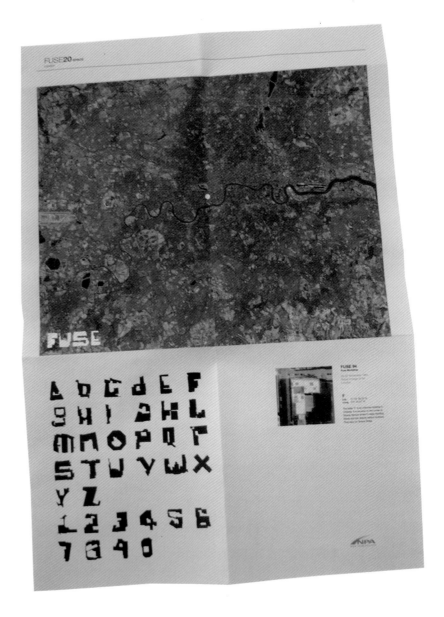

Work Theme Description
FUSE20 is the twentieth issue of Neville Brody's renowned experimental typography publication; this project focuses on the FUSE conferences which have been held in four major citie
The project carefully observes and celebrates the fundamental component of typography: space.
Four double-sided folded posters exhibit four complete alphabets, constructed and collated from the aerial views of four cities through Google Earth: London, Berlin, San Francisco a
Tokyo. These alphabets were created solely from the mapping of the buildings and the spaces between them.
When all four alphabets are displayed next to each other, the distinct structure and quality of each is revealed, reflecting the past and present economic state of the city. Consequenc
of past wars, accessible materials, geographical composition and architectural grid systems are the cause for these variations in space and contrasting alphabet structures.
Space is the critical feature of this project; an entire alphabet, every character that enables you to speak and communicate, can be built from your surrounding urban environment.
The FUSE20 logo was created by selecting a letter from each alphabet. These particular letters were researched in detail and explanations to their exact location and building descripti
are on each poster.

Faculty Adviser Dave Herbert
Presentation Media 4 × A2 posters to be hung
 1 × fold out publication
 1 × poster type alphabet presented in case.
 Case dimensions: 55cm(l)×33c(w) ×8cm(h)
Exhibits Dimension 4 × A2 posters
 1 × fold out publication (slightly larger then A4 when sitting on its stand).
 1 × poster type alphabet presented in case.
 Case dimensions: 55cm(l)×33c(w) ×8cm(h)
 Case is to sit on waste height plinth alongside the publication with the four posters presented on wall above.

Memory - Space
记忆-空间

Author Dalius Ripley

Work Theme Description
Located in the city of Glasgow, Scotland, UK, this project proposes a purpose built facility for appreciation of contemporary music which will contribute to the regenerating-urbanization process of the region. As an on-going global phenomenon, urbanization does not merely involve an increasing population living in cities and the suburbs of cities; it also has been closely connected with both the improvement of human productivity, and with problems such as high
dependency amongst the congregated population as well as isolated individuals. The modern approach to the trend is to avoid isolation by providing more vibrant communities within the city.
Inspired by the memories and feelings associated with music, the design explores the ways in which architecture may encourage interaction among people, between the building and people, between the man-made and the natural. By redefining the space through light and dark, opening and enclosing, in the context of the expanding city, the work aims to bring back the memory of interlinked community life and generate individual identity, something which has been lost in our modern society.
The building combines both public and private roles, illustrated by three main elements: music school, public area and the route connecting the contracting environment.

Faculty Adviser Jeanette Paul
Presentation Media Etching on white paper.

Exhibits Dimension Concept diagram 375mm × 485mm
Gr floor plan 750mm × 1050mm
Plans & sections 565mm × 380mm
Site & 1 section 765mm × 565mm
4 elevations 115mm × 765mm

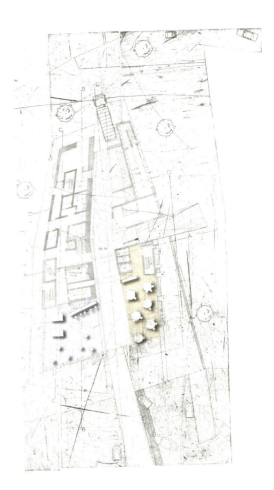

Non-places
虚无空间

Author Dave Anderson

Work Theme Description
The overlooked and understated elements of the city form the focus of my artistic practice – the car parks, alleyways, stairwells and underpasses that are an intrinsic part of our built environment. Existing as neither home nor destination, these non-places are a factor of our cities that is becoming ever more prevalent with the increasing anonymity of urban living.
My work aims to address these places and assert their existence alongside the landmarks and tourist attractions. Painting is a highly personal activity, involving a physical process of creation; marks, smears, fingerprints, blobs and splatters all form part of a tapestry that is used to create the image, a likeness of the subject but transformed. Through painting I am attempting to humanise these essentially inhuman aspects of our urban landscape, where innumerable individual contacts overlap but never relate.

Faculty Adviser Tracy Mackenna
Presentation Media Oil on Canvas
Exhibits Dimension '1/2, 7, 1/2' -1550mm × 1550mm
 '6' -1550mm × 1550mm
 '7, 9' -1830mm × 1550mm

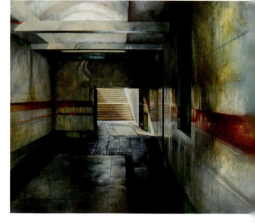

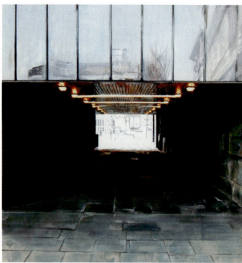

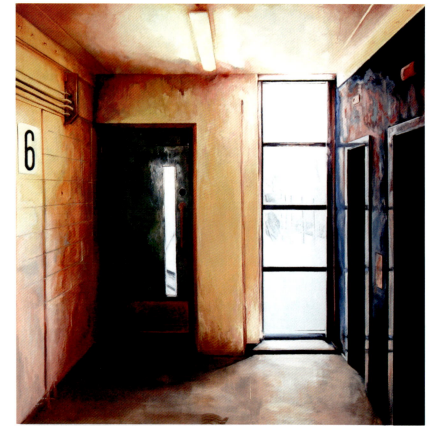

Architecture at the Coast
海岸边的建筑

Author Gavin Pettigrew

Work Theme Description

Rothesay on the Isle of Bute, West of Scotland, UK, was once a prosperous coastal town, but now its community is facing a challenge to redefine its economic and social purpose, as traditional industries face major change. This project aims to explore the way that the coast has impacted on the social, cultural and industrial development of Rothesay, upon how people's relationship with the coastal edge might develop. Addressing the topic by interrogating a particular site within the broad context of influences and, more narrowly, in relation to a specific theme. A new luxury hotel and spa facility will be designed to reconnect the old 1930's disused bathing station with the urban fabric and to re-establish its cultural past into the 21st century. The complex and layered cultural design process of the seaside spa will allow one to explore a combination of senses that make the spa successful, so that the sea air, sea view and sea water inspire, amuse, rescue, frighten and challenge the guest, offering temporary respite from urban life.

Faculty Adviser Graeme Hutton
Presentation Media A0 paper, A2 paper, A3 paper
Exhibits Dimension 841mm × 1189mm 420mm × 594mm 420mm × 297mm

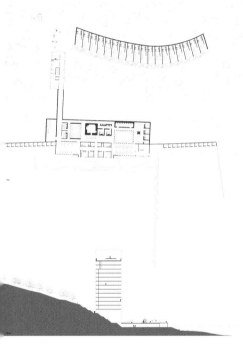
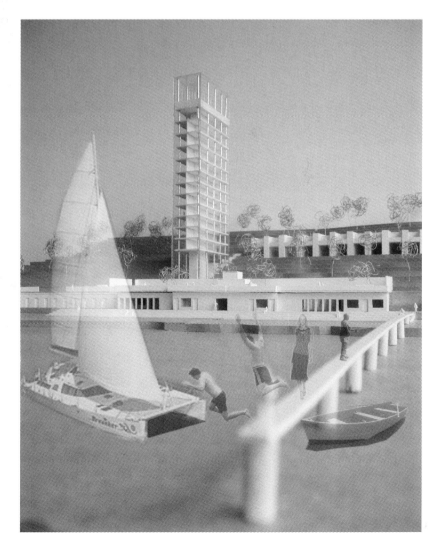

Sky Road
天路

Author Nicola McCabe

Work Theme Description
This project considers how changing a small daily action in a city in Scotland, UK would have a positive impact on the urban environment. In this city, 65% of school children are driven to school with most journeys being less than three kilometres. Only 1% of children cycle to school. My research identified that parents consider it is unsafe for children to cycle on roads.
My solution to the problem is 'Sky Road', an elevated cycle track raising cyclists above the dangers of vehicular traffic. Stations are located around the track where bikes can be hired and returned, similar to the community bike sharing systems in Paris, (Velib) and Barcelona (Bicing).
The 'Sky Road' aims to provide a safe cycling haven for school pupils and commuters and encourage cycling as a viable mode of transport. With problems of traffic congestion, this could provide a much faster way to travel, creating a more effective flow of people around cities. It also aims to promote active lifestyles and help to fight the country's battle against obesity.
Additionally, the 'Sky Road' could encourage a sense of community; cycling alongside others and sharing community bikes engages people a more intimate level than cars passing anonymously on a road.

Faculty Adviser Roland Ashrcroft
Presentation Media Video and images
Exhibits Dimension Screen

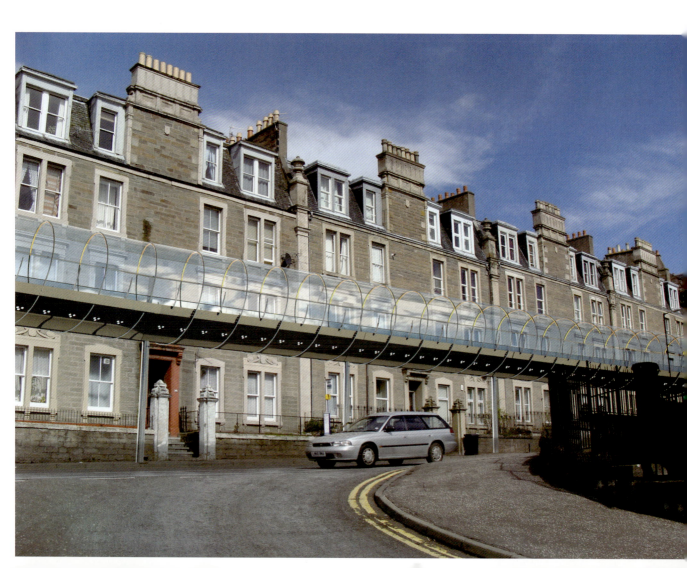

An Archaeology of the Present
现代考古学

Author Ross Brown

Work Theme Description
The wastelands and abandoned places on the periphery of the city shore the fragmented fall out of contemporary life; they are physical reminders of the instability of our dwelling places. The fragility of the worlds we build to inhabit (both in the macrocosm and within ourselves) is most evident within these landscapes of refuse, the changing forgotten.
"Memories are motionless, and the more securely they are fixed in space, the sounder they are."
The painting, like memory, is unchanging. It is a fixed puddle of liquid and as a result, wholly uninhabitable. To "fix" these forgotten places within the painted surface contradicts their nature in reality. But the wasteland is in a constant state of flux: nature reclaims broken concrete; wind disturbs the surface of the pool.
"To recognise the past, out of the cloudy horizon of the present, would mean to bring about its

Faculty Adviser	Jeanette Paul
Presentation Media	Oil paintings on canvas/board
Exhibits Dimension	Paintings range from 1520mm × 1220mm (smallest) to 1830mm × 1520mm (largest)

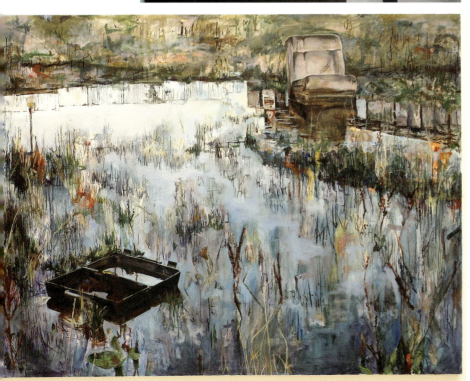

City as Narrative Realm
城市，作为一种叙述领域

Author Victoria Marshall

Work Theme Description
We gain and collate our knowledge of the city and its streets, either consciously or unconsciously, through peripatetic movement or within the romance of flanerie. The research/design project proposed to investigate the city as a narrative realm and the interdependent relationships between the built form and external spaces within an urban context. Cities hold many stories, however, they are not just romantic notions, they are part of everyday life. Individual stories are written and intertwined within the city streets, creating memories and spatial stories.
The Walker of the city was used as a starting point for research, looking at the eighteenth sensibility of the Flaneur and the relationship between The Walker, The Writer, and The Image of the city. Within looking at the work of writers, artists and photographers it is possible to see stories within the city that otherwise get overlooked. Attuned observers of their environment, they communicate their understanding through written and visual tools, characterising the essence of the urban realm. A holistic design process was taken, using visual and written narratives as a precedent and as a design tool to create stories and imagined narratives. The aim was to design as a walk through, letting the story define the built form.

Faculty Adviser Graeme Hutton
Presentation Media Wall mounted drawings
Exhibits Dimension 2400mm × 2400mm
　　　　　　　　　5 at 210mm × 1682mm
　　　　　　　　　1 at 594mm × 1682mm
　　　　　　　　　1 at 594mm × 594mm
　　　　　　　　　1 at 2000mm × 594mm

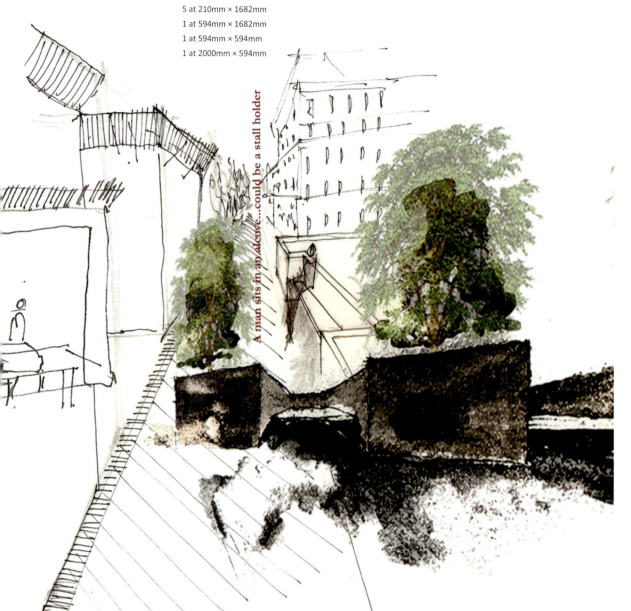

Untitled
无题

Author Bianca Hester

Work Theme Description
Untitled
Mixed media
Size variable

Faculty Adviser Lesley Duxbury
Presentation Media Book and poster

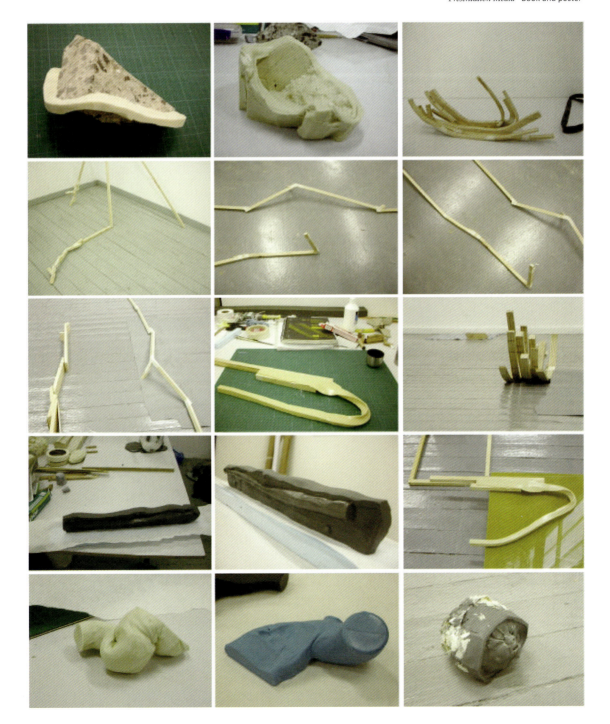

Exhibition Installation
展览装置

Author Fleur Summers

Work Theme Description
"Exhibition installation"
Mixed media
Size variable

Faculty Adviser Lesley Duxbury
Presentation Media Book and poster

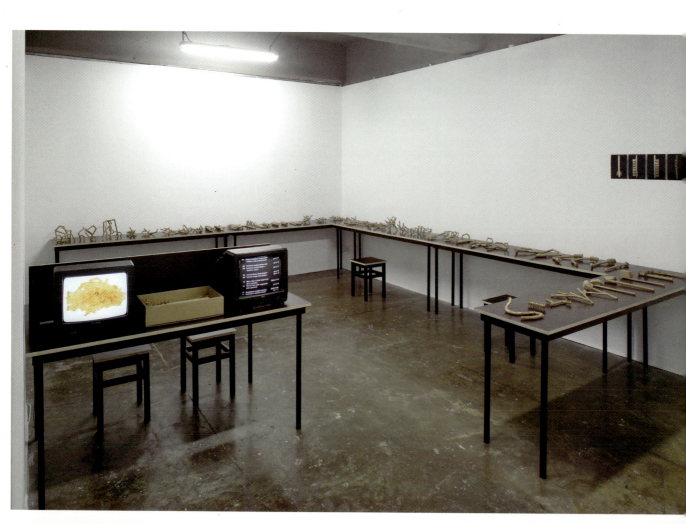

Recombination:
Towards Contemporary Group Form
对当代组织形式的重新整合

Author Han Li

Work Theme Description
This research offers methods and strategies that are developed in response to a series of topical contemporary architectural and urban issues in order to pursue more adaptable, heterogenous and dynamic organisational systems, termed "group form".

Faculty Adviser Andrea Mina
Presentation Media Book and poster

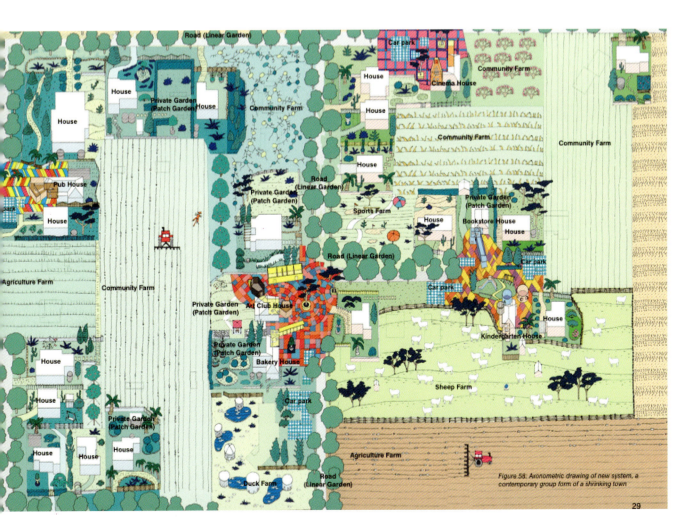

Figure 58: Axonometric drawing of new system, a contemporary group form of a shrinking town

Entity 4
存在 4

Author John Waller

Work Theme Description
"Entity 4"
Screened interactive computer animation
Size variable

Faculty Adviser Lesley Duxbury
Presentation Media Book and poster

Transparent House Image 2
透明房屋图像 2

Author Maria Pena Briceno

Work Theme Description
"Entity 4"
Screened interactive computer animation
Size variable

Faculty Adviser Andrea Mina
Presentation Media Book and poster

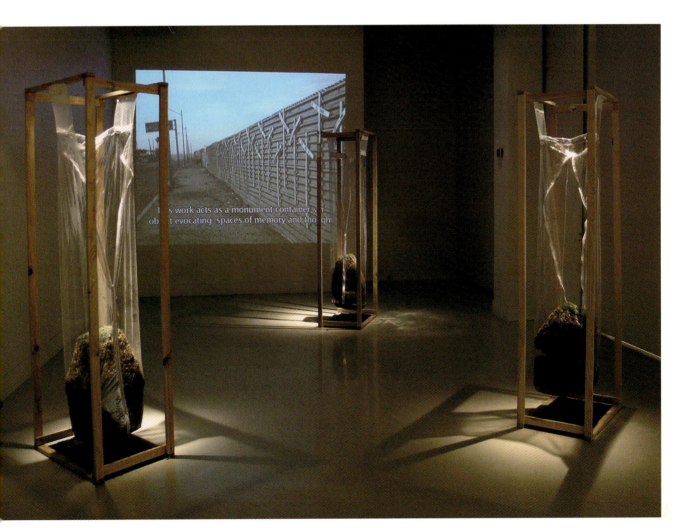

Inside and Outside 3
內外 3

Author Mon-Xi Wu

Work Theme Description
"Inside and outside 3"
Raku clay, crackle glaze, slips 55 × 33 27cm
Size variable

Faculty Adviser Lesley Duxbury
Presentation Media Book and poster

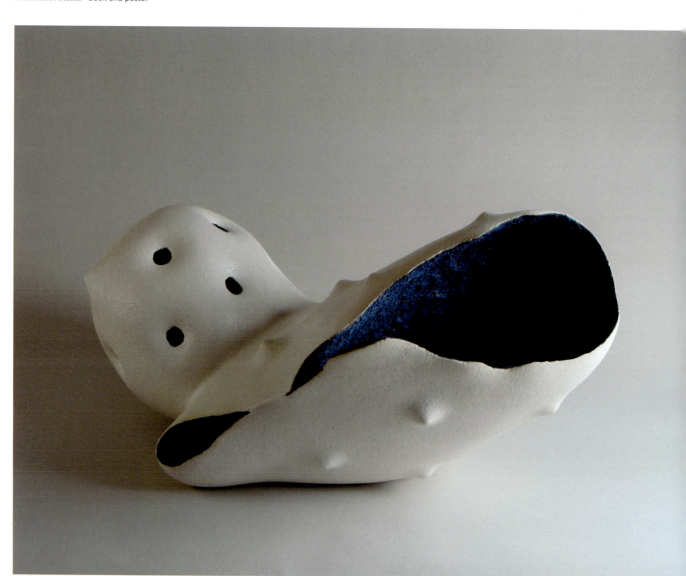

Reifications
具体化

Author Paul Minifie

Work Theme Description
These projects approach the doing of architecture as a kind of techne trouve or strange procedure. This research examines architectural composition in the context of emerging technologies and practices through the undertaking of a series of design project case studies.

Faculty Adviser Andrea Mina
Presentation Media Book and poster

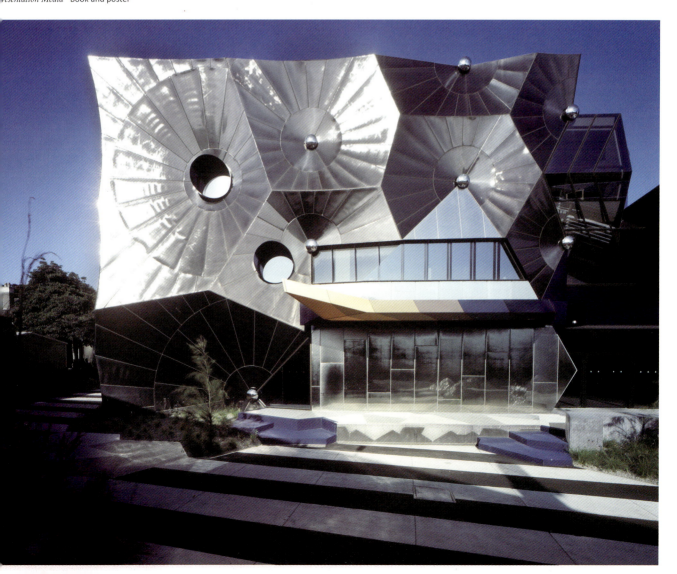

Wall
墙

Author Phillipa Murray

Work Theme Description
Wall
Acrylic paint
Size variable

Faculty Adviser Lesley Duxbury
Presentation Media Book and poster

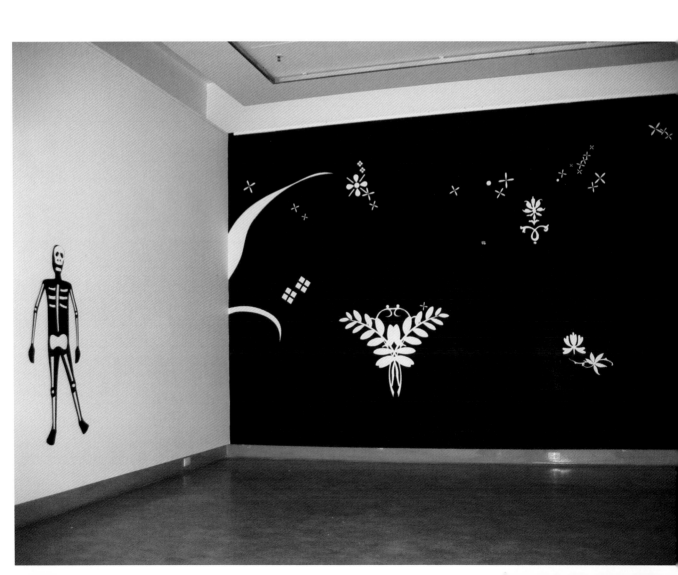

Seedtime:
A Dynamic (Urban) Organisation
播种时期：一个有活力的城市组织

hor Qing Sheng He

rk Theme Description
w can an adaptive urban morphology of organization be developed that has the capacity to increase the use of the site (as astructure) in Shanghai over longer periods of time?

ulty Adviser Andrea Mina
sentation Media Book and poster

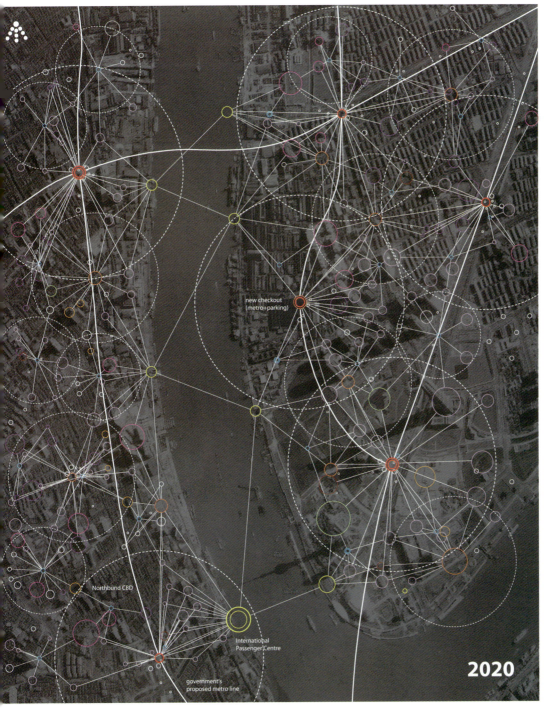

network

Land area: 6.5 sq. kms
Population: **0.2 million**
Number of checkouts: 6
Number of supermarkets: 6
Number of public car parks: 12
Number of bus stops: 28
Number of ferry terminals: 6+1

- Metro station
- Major transfer station
- Green Park
- Bus stop
- Bus terminal station
- Car park
- Commercial office
- Service apartment
- Local school (P&H)
- Cinema & Entertainment
- Hotel & Restaurant
- Ferry Terminal
- International Passenger Centre (2020)

2020

120 Where Things Stop and Start
事物开始与结束的地方

Author Robin Kingston

Work Theme Description
Graphite, gouache, watercolor and acrylic
Size variable

Faculty Adviser Lesley Duxbury
Presentation Media Book and poster

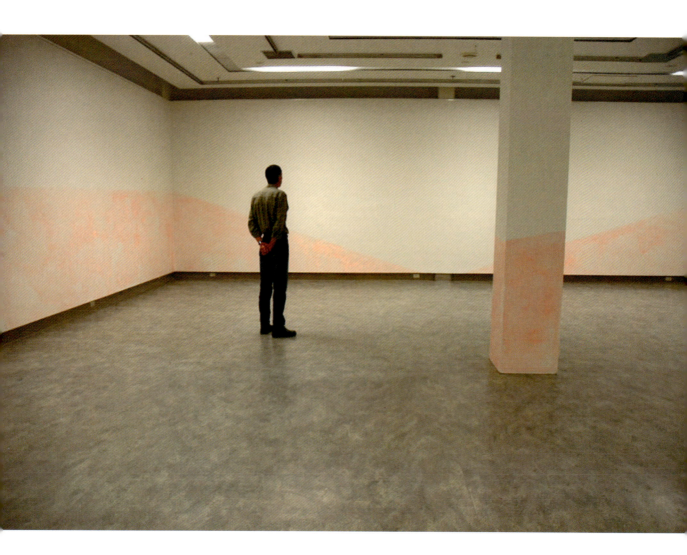

Negotiating Space - An Interior Practice
洽谈空间——室内设计练习

Author Roger Kemp

Work Theme Description
Negotiating space - an interior practice. [Looking into - looking through]
This Masters proposes a drawing strategy that considers, constructs and documents relations in space as a way of imagining and embodying the potential of spatial and temporal conditions, and which can in turn contribute to the design of interiors.

Faculty Adviser Andrea Mina
Presentation Media Book and poster

Architectural Design and Discourse
建筑的设计与讲述

Author Shane Murray

Work Theme Description
This research proposes a methodology by which an individual design process can be enquired into and described, that might be applied by others to develop a body of discourse contributing to the understanding of architectural design processes. This is undertaken through a detailed account of the design of a series of projects that is directly connected to actual issues that influenced design composition and formal execution.

Faculty Adviser Andrea Mina
Presentation Media Book and poster

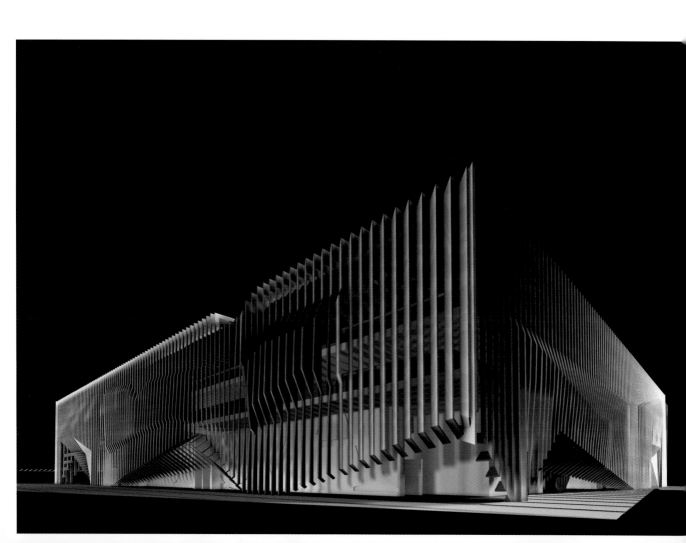

Anti-memorials:
Re-thinking the Landscape of Memory
反纪念：关于记忆景观的再思考

Author Sue Anne Ware

Work Theme Description
There is an incongruity between the inherent changeability of landscapes and memories and conventional formal strategies of commemoration. If we think of memory as not some platonic ideal that is pure or complete, but a periodic process of re-evaluation and reconstruction given present contexts, do our ideas about designing memorials evolve? My research and design work tries to negotiate with the slippery qualities of memory as a way of generating memorial form. It speculates on new programs for memorials which include temporary and ephemeral processes.

Faculty Adviser Andrea Mina
Presentation Media Book and poster

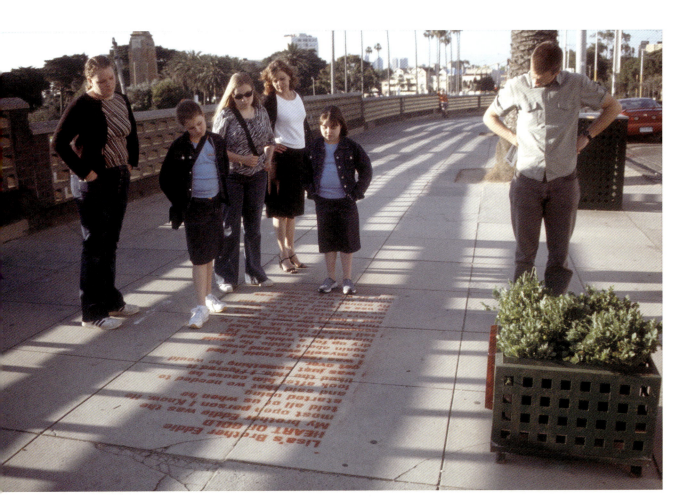

Terroir as a State of Mind
作为一种思维状态的Terroir

Author Scott Balmforth & Gerard Reinmuth

Work Theme Description
This research uses current office projects by Terroir as exemplars of the presentation of our ideas and methodology, to seek critical accounts of what we do and propositions to assist us in using our state of mind as a platform for further innovation in an expanding and evolving practice.

Faculty Adviser Andrea Mina
Presentation Media Book and poster

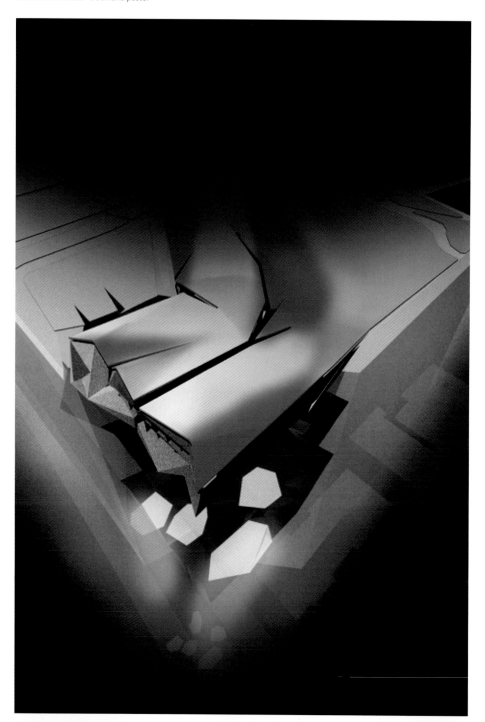

Materialising the Un-Australian
物质化的联合国澳大利亚

Author Roseanne Bartley

Work Theme Description
"Matterialising the Un-Australian"
Sterling silver, brass, silk
80mm × 12mm

Faculty Adviser Lesley Duxbury
Presentation Media Book and poster

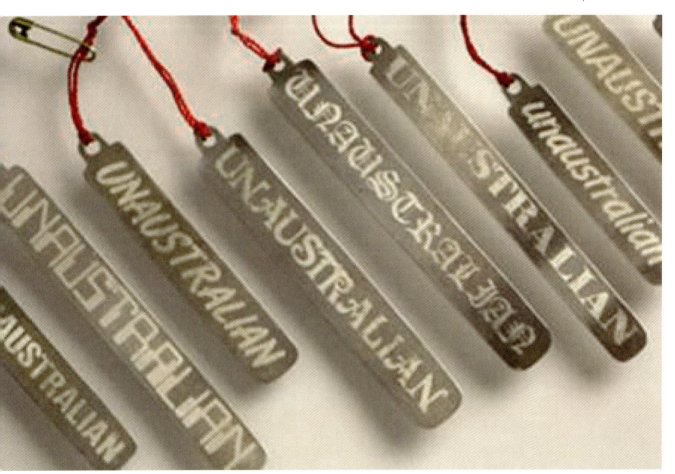

Biblio Graphic
书志目录平面设计

Author LU Yiying Amy Cook

Work Theme Description
This research uses current office projects by Terroir as exemplars of the presentation of our ideas and methodology, to seek critical accounts of what we do and propositions to assist us in using our state of mind as a platform for further innovation in an expanding and evolving practice.

Faculty Adviser Louise McWhinnie
Presentation Media Book Format Digital Vector Artwork
Exhibits Dimension A3 X 20

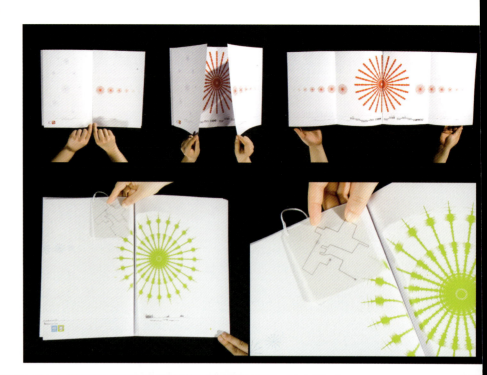

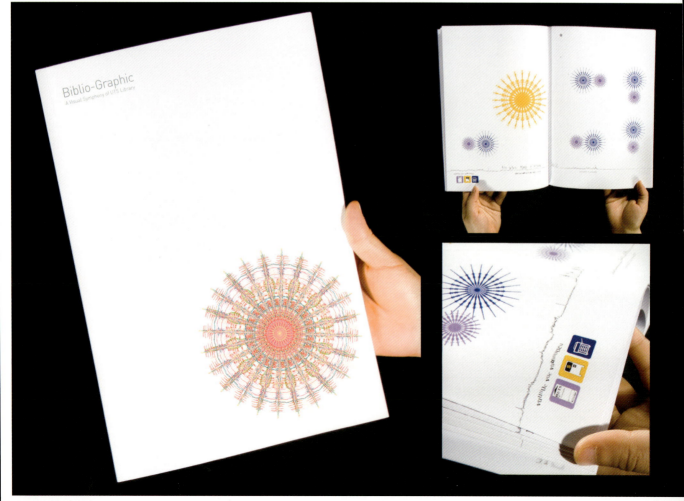

All in a Suitcase
一切都在行李箱里

Author　Paola Monti

Work Theme Description
According to the trans local motion topic All In A Suitcase's covering structure is conceived to be easily transported in a suitcase whilst using discarded material found on site as filling.

Couch: fabric, straps, mattress
Side Table: PMMA/wood, fabric, PET bottles

Interactive Design Project
交互设计项目

Author Mand-Anorea Bidet

Work Theme Description
Creativefeed / creative intelligence solution
Creativefeed is a multi-support data aggregator that applies business intelligence techniques to the creative field.

Umob / Interactive mobile game for airport travelers
The Umob project intends to follow this new trend by proposing an interactive mobile game to guide travelers while bringing some fun into airports, places where a great diversity of human beings come into contact and where many experiences can occur.

Vibrations culturelles/ cultural calendar
Vibrations Culturelles is a versatile Internet application enabling users to scan the cultural life of a city in no time by visualizing events through a geographical or a theme-based mapping system.

Faculty Adviser Christian Guellerin
Presentation Media Pictures on cardboard
Exhibits Dimension 5 boards (1000mm × 200mm each)

Creativefeed

Umob

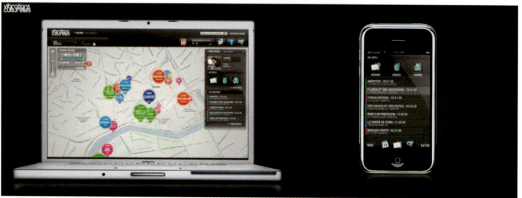
Vibrations culturelles

The CityCab
城市出租车

Author Mr Suomala, Timo Mr Santamala, Harri

Work Theme Description
Today, public transportation in most metropolitan areas is fluent, but using a private passenger car is more and more problematic. This underlines the importance of a functional taxi system. A traditional passenger car, or a van transformed into a taxicab, is not by far the best solution. What we need is a special vehicle, similar to the London Cab, but redesigned and equipped with the latest technology. Helsinki Polytechnic and the University of Art and Design Helsinki share a common view of the next generation metropolitan taxicab - the CityCab. Introduced first time in Paris Motor Show 2006, the concept has been estimated to be what the passengers and drivers really want. In Frankfurt customers could experience the CityCab in traffic by themselves!
The 21st century taxicab needs to be environmentally friendly and safe. CityCab's fuel consumption and emissions are both extremely low thanks to the hybrid powertrain by Toyota and the vehicle's ultra-light body. The carbon fibre composite body manufactured by using a novel SPRINT technology weighs 75% less than a steel body and it's also cost-competitive. The vehicle's crashworthiness has been determined through computer simulation tests.
CityCab is not merely a prototype show car, but a fully functional and registered research vehicle. Immediately after IAA a full scale research work will start in Finland. Drivers working environment, customer service operations, traffic ability and travel order procedure are typical topics, when CityCab will be compared to conventional taxicabs. Until now, 56 companies are involved in the project.

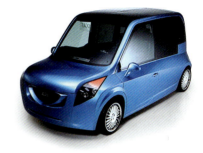

Faculty Adviser Professor Raimo Nikkanen (TaiK) Course Leader Matti Parpola (Stadia)
Presentation Media Pictures, photographs, scale model

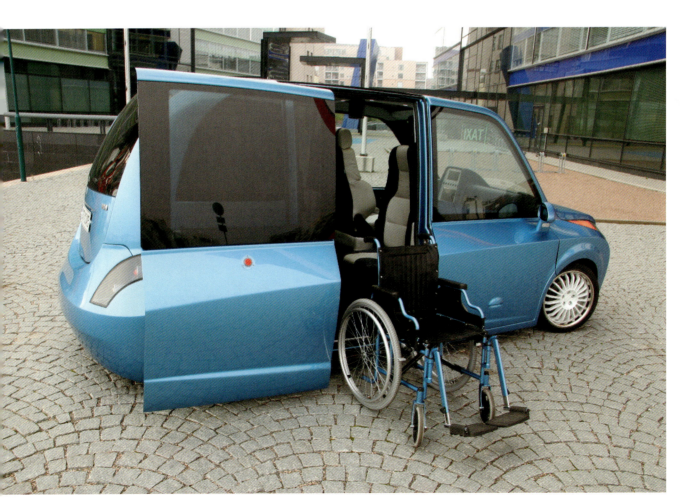

The Sauna Bus
桑拿巴士

Author Mr Paakkanen, Mikko Ms Pokela, Laura Mr Laakkonen, Mikko Mr Salonen, Jussi Ms Kosonen, Krista
 Ms Kurahara, Tokomo Mr Aalto, Klaus Ms Nuutinen, Paula Ms Huber, Sasha Mr Tolonen, Hese

Work Theme Description
The Sauna Bus is a deconstructed and customized old bus metamorphosing a unique mobile home, which has a strong but fresh and unconventional Finnish identity. It is a streaming urban design exhibition on the road. At the same time is a sauna in the bus, where you can sleep and cook on the way to the destination, or any destination you decide to choose. It is a suggestion to rethink urban life and services and revitalize used articles through new design concepts. The Sauna Bus has been invited to several major cities and design events: Milan Furniture Fair, Designmai, International Design Festival in Berlin, Cologne International Furniture Fair and Moscow and has offered a unique possibility to all sauna-lowers open minded people an experience never to be forgotten...

Faculty Adviser Professor Timo Salli
Presentation Media Text, pictures

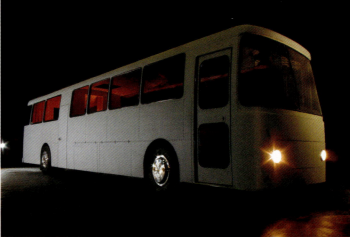
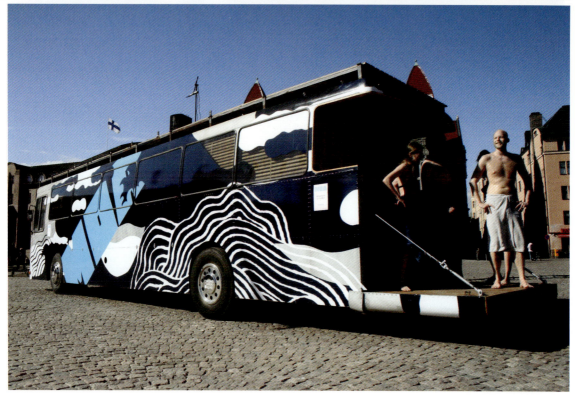

Street logic
Author Rikard Zetterlund

Blade
Author André Harley

Greenbow
Author Philip Kongsgaard D.ssing

Squid
Author Martin J.rgensen

Magic Shoe/
Ten Bikes: a Co-operative Project
魔鞋/
10辆自行车：合作项目

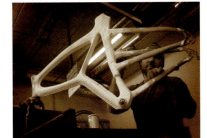

Work Theme Description
A bicycle is like a magic shoe that allows us to move at speeds and distances that are otherwise unattainable for humans. In 2006 Designskolen Kolding and Kildemoes (a leading Danish bicycle manufacturer) teamed up in order to work on new ideas for a set of bike designs for the Scandinavian market. The underlying goal of the project is to renew the archetype of the bicycle and place it in a relevant Danish context where cycling is considered a national pastime and is still a common way of commuting.
Around the world one of the most easily recognised images of China is of thousands of people travelling to work on bicycles in the major Chinese cities. China is changing rapidly and methods of travelling are changing too. Cars fill the cities of China in ways that were unimaginable two decades ago. For this reason we hope that Ten Bikes will awaken folk memories of these journeys and encourage bikes and their riders to reclaim the streets.

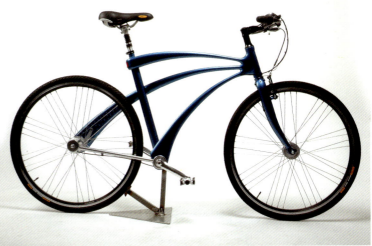

Central Park, as a Living Organism
纽约中央公园规划

Author Griffin Frazen

Work Theme Description
Theoretical architecture; global urbanization research and design science.
This project is based on the belief that parks should exist as natural environments that serve to foster a more bio diverse community. The notion of the park as an artificial preservati (a replica) of nature for recreational purposes should be abandoned. Manhattan's Central Park is perhaps the clearest example of a taxidermic preservation of nature. " A catalogue natural elements is take from its original context, reconstituted and compressed into a system of nature that makes the rectilinear of the Mall no more formal than the planted informal of the Ramble." (Rem Koolhass, Delirious New York). There is a clear separation of the city from the park. Its only connection to the grid is the roadway system that allows for vehic and pedestrians to cross in and out of its borders.
This project examines how agency flow between the circulatory systems of Manhattan and Central Park may disrupt or mutate the environment. The project considers Central Park a living organism--a complex system at work--and posits that the current condition of urbanization and over population can be used as a growth model to provide a reversed transform tion, wherein the park grows and spreads in the city grid maximizing bio diversity and literally intertwining the natural with the artificial, the organic with the man made. "You can nev direct a living system; you can only disturb it." (Maturana & Varela, Tree Of Knowledge).

Faculty Adviser Dr. William Rayner
Presentation Media Digital and/or print media, small model (3D print)

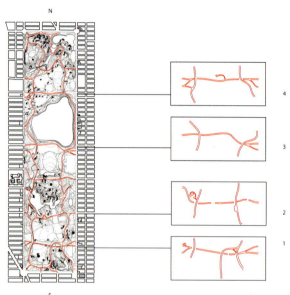
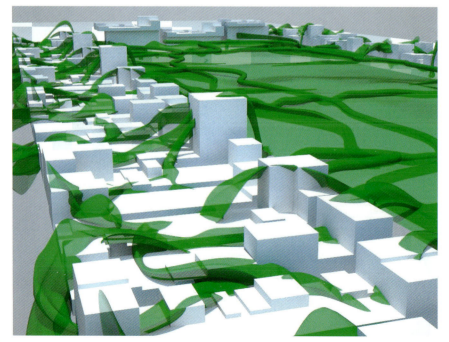

Bus of the Future: 2050 /
Shenzhen Mobilty
2050年的未来巴士/
深圳的流动性

Author Gabriel Wartofsky

Bus of the Future: 2050

Work Theme Description
Using the events pertaining to the 80th Anniversary of the Santa Monica Big Blue Bus Company as a contact point with the bus-riding public, to research, consider and then propose alternative designs for the company's future bus fleet.
These design proposals have the opportunity to inspire positive public debate and anticipation of the future of bus transit. In turn, such public inspiration, along with the best of the bus design proposals could lead to the next phase of a design collaboration with the American bus manufacturing industry.

Shenzhen Mobility

Work Theme Description
Gabriel Wartofsky's project for addresses congestion in the Futian District of Shenzhen, China, is a good case in point. Collaborating with the Dean from of Architecture from the University of Southern California, I developed 3 main concepts, ranging from blue sky to tech-based to utilizing existing infrastructure, to streamline the daily commute of people working in Futian.
These were as follows:
1. Blue Sky
2. Air Bridge
3. Luxury Taxi Service

Indy Project/
Deus ex machina
印地赛车联盟赞助项目/
舞台机关送神

Author Team One from the students from Art Center's Transportation Design, Product Design, Environmental Design and Entertainment Design departments.

Indy Racing League Sponsored Project

Work Theme Description
Author Team One from the students from Art Center's Transportation Design, Product Design, Environmental Design and Entertainment Design departments.
This trans-disciplinary project sponsored by Indy Racing League challenged students from Art Center's Transportation Design, Product Design, Environmental Design and Entertainment Design departments to rethink all aspects of open wheel racing, from the racecar to the track to the total fan experience. Six teams of students came up with a wide array of solutions to this intriguing and exciting request.

Team One: Heroes
This team focused on the Indy driver as a hero in the comic book sense, using traditional elements of comic book design in their solution.

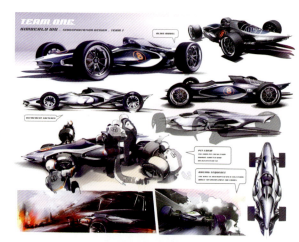

Author Jake Loniak

Deus ex machina /

Work Theme Description
The name Deus Ex Machina, literally translated "god out of a machine," is rooted in Greek tragedy after the machine that would lower an actor portraying a deity onto the stage. This vehicle was so named because of the way the rider is presented upon coming to a stop. Designed by Art Center College of Design student Jake Loniak, the Deus is an electric, single passenger, vertically parking, wearable motorcycle.

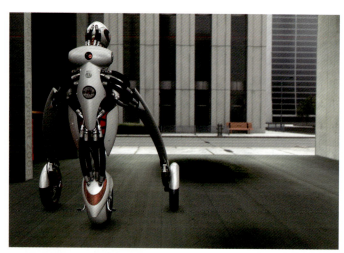

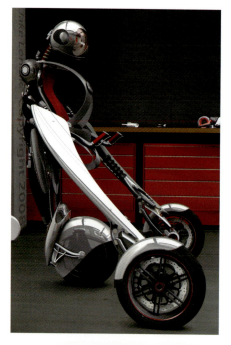

Common Social Problems
in Megacites, Hypercities
大城市共同的社会问题

Author Jonas Baumann

Work Theme Description

I emenate from a statistic released from the United Nations who says that more than 50% of world population live in cities and this number is set to rise to 75% by 2050.
So the main thing I think abouth is: how can I deal with the fact that we are surroundet of big and fast growing cities who absorbing every space arround itself?
- So the first step for me is to visualize the problem to be aware of the fact.
I made a big and loud poster who shows a city expanding, showing the winners and the loosers of this developement. With the funds of collage, taking material from existing urban spaces, I want to show the real background and a let the picture connecting to reality.
The second thing I think abouth is: when I get absorbet what may expect me in there and what is my personal view on possible problems?
- So I collected remarcable statistics from big and fast growing cities all over the world. To every single statistic I added a personal commentary using pen and paper and with this images I build a new city myself. This imaginary city unites all common social problems of today metropols. The pictures i draw are partialy suspected solutions and partialy problems consequences.
It just shows my perception to actual city development all over the world.

Presentation Media Printed Posters, Book

Exhibits Dimension About 7 pieces - glass case for originals, table for the book (36 pages) and
a wall for max. 3 DINA2 posters

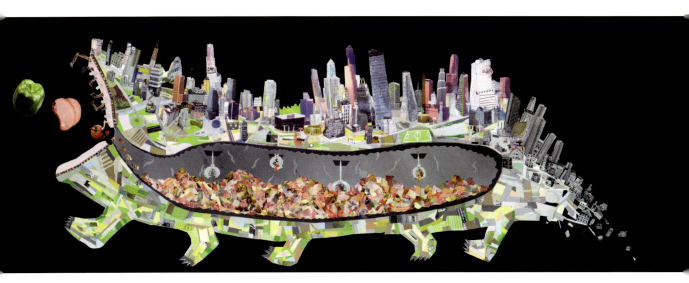

Flower 2.0
花 2.0

Author YANG Wenqing
　　　　 杨文庆

Work Theme Description
The transition of people is always closely related to the transition of space and time. More and more advanced transportation tools and network make this process easier and easier, but the existence and development of virtual world is challenging this process continuously. Project flower 2.0 is a kind of prototype. The design, trying to interact with the potential users from the very beginning, presents a generally created mode. Flower 2.0, composed of entity products and a virtual network, is a platform for interaction, by which the user can continuously enrich the feeling and create new experiences beyond the space and time.

Academic Advisor　Ronald Jones

The Embeded Media Master Elective 2008
嵌入式媒体设计2008

Author Randi Grov Berger Memona Khamara Therese Kristiansson Kristoffer Svenberg
 Cameron Macleod Wenqing Yang

Work Theme Description

Airports, they are no-places...
But, are they not?
People by the billions who pass by airports every year do leave no traces behind them; they take nothing but photographs, they leave nothing but footprints, they kill nothing but time...
Or do they, really?
"Traces", a Embedded Media project will use embedded messages to pursuade passengers at Arlanda Airport to question themselves.
As a passengers, you always find yourself in a big hurry here and there between airport gates, but when you are finally at your "own" gate, you do have time left.
Well, that's the meaning, even though more often than not, you have got more time than what you have wished...
Especially when you find your flight being delayed...
So shake yourself lose and try out your witty dance steps on an embedded "Emotion Machine", a concept developed at this Embedded Media Master Elective...

by Randi Grov Berger

Going to Arlanda - research

Trying to analyze the airport for this task I put on my critical glasses when visiting Arlanda. It's easy to start looking at all the negative stuff because then you can help out with solutions. How are people spending their time in the airport, how is the food here, how are the prizes, how does it work with information, signs to follow, distances to walk, security, sound volume, noise, seating areas, communication, internet access, families with children, children traveling alone, VIP lounge, toilettes, trolleys, air, coffee(important for some of us) and on and on...
Being aware of the climate changes you can`t get away from the fact that all airports are a big part of an industry that is affecting the environment badly. Yes, they are not the only responsible ones for the CO_2 being put out into the atmosphere, but airports are such a big part of this travelling industry that they have some influence on both companies and passengers.

Starting the design task

The first idea I had for doing something at the airport, was to comment upon the fact that this place is becoming more and more of a super modern place. It is a place for consuming. It is also really high tech area with a lot of security systems, electricity and with wireless connection in the whole building. I wanted to make a media-less place. A big faraday box with no wireless internet, no electromagnetic waves, no electricity and with only a small amount of light. A calm place, a place for gathering your thoughts and get away from the static electricity, commercials, perfume smells, light flashing, visual disturbance and the mass of people! I soon understood that this place/ room would not meet the airport´s own wishes. Because I by proposing it, am beingcritical to the fact, that the airport outside this box, is not a good environment to be in.

A soundscape

A scape is a way to focus on aspects of the dynamic relationship between the participant and the environment. There can be as many scapes as there are senses. Landscapes concerns vision, smellscape concerns odor and soundscape concerns hearing. Scapes can be understood as the spatial configuration of an environment related to an isolated sense. The scape is a particular way of spatially relating the observer, or the participant to space and time. When we move in an environment all objects we see have their own sound so that image and sound evolve together in time and space.
With the blend of the installed "The Interactive Soundscape" and the existing sonic environment it will result in a displacement of hearing and seeing.
It is in this confusing moment we hope people will get an experience.
We all use sounds, to get connected, to get attention and thus gain articulation from the surroundings. Through this game for attention
and identity, the relationship between the public
and the private spheres are negotiated and reconfigured.

Posters for Collective Reconciliation
为集体和解而作的海报

Author ROJAS MU.OZ MAURO

Work Theme Description
10 unique posters handmade with a high reference to urban art and graffiti, conceived as a concept of advertising, the objective is to call for the order to thecivilization for the respect and tolerance of each individuals to live with harmony in the urban territory between different cultures and also respecting the natural environment.

Faculty Adviser Sophía Galárraga, Coordinator of Graphic Design

Presentation Media 10 Posters handmade of 130cm height and 90cm weight each poster

Exhibits Dimension 15m weight – 1.3m height

Embroideries
刺绣

Author Marinke van Zandwijk

Work Theme Description
A flourish besides your schoolwork as a sign of approval and appreciation.
Appreciations which were made of glass and embroided on a frame with a thread of silk; used as a metaphor and referring to Life and Wisdom.

Presentation Media Glass and silk on an embroidery-frame.

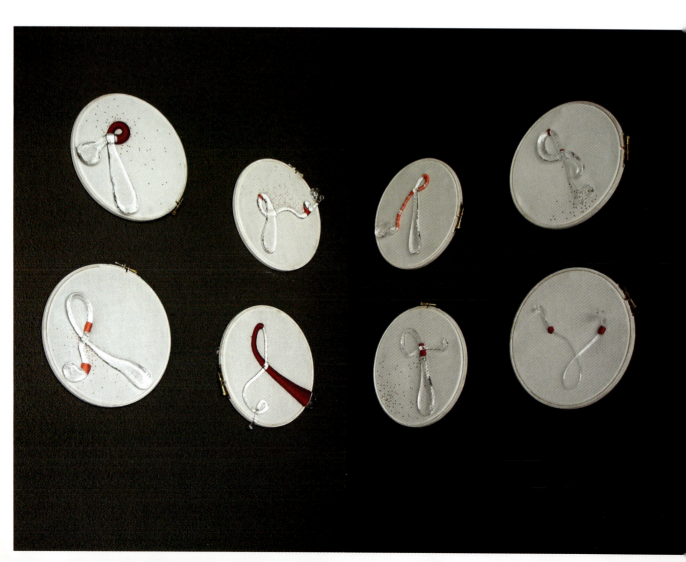

The Myth of a New Nation
一个新民族的神话

Author Bouke Verwijs

Work Theme Description
Portraits.

Presentation Media Pencil on paper

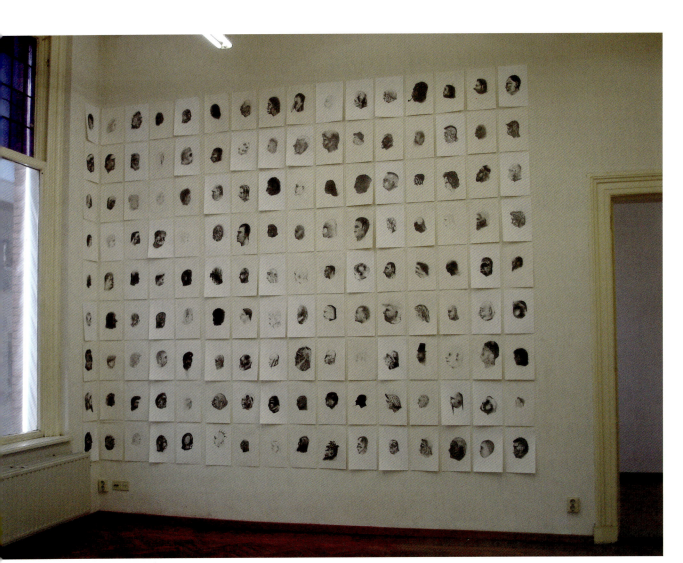

Communication Model
沟通模型

Author LUO Yan

Work Theme Description
Communication Model is about the dichotomy there is between the capabilities as individuals to be simultaneously in many places at the same time and yet to a reduced perception of the world as a result. As Paul Virilio stated, referring to time-spae compression, in an interview with James Der Derian, 1991: "We are going to be living in a reduced world. The capacity of interactivity is going to reduce the world, real space to nearly nothing."
Communication Model is an interactive project which intends to explore the idea of a reduced world. The project consists of the dynamic relationship between background and foreground, background being the existing condition of human experience, and foreground being the constant transformation of that existence. By clicking the mouse and moving it on the screen, the viewer engages with the paradigm of Communication Model.

Faculty Adviser Edison del Canto
Presentation Media Interactive Flash on laptop/desktop

Exhibits Dimension 16 × 22''approximately

Mobile Phone Booth
移动电话亭

or ARCH 206 Design II, Class of Spring semester 2007
 Hamad Hulaibi et al.

lty Adviser Quinsan Ciao

Theme Description

ground: Cellular phone technology has become a way of life in terms of its functional convenience and its cultural impact.
el features, techie gimmicks and latest trends arrive and update rapidly. It has brought also social behavior /urban environ-
tal issues and demands for positive architectural/design interventions. How we can facilitate and design for the need of the
ern mobile phone users in the public places should be explored and experimented.

gram: A set of 3 to 5 "booths" for users to make any necessary tasks of using their mobile phone, such as calling, browsing,
 tooth transferring (?), text messaging, ... or simply relaxing.
r may be in the position of sitting, standing, leaning, ...
vide relative privacy and quietness but not isolated and closed
w booth-to-booth blue tooth file transfer
courage appropriate manner and positive mobile phone using etiquette

ce: Each booth allow 1-2 users, approximately 0.7-1 m2
 Individual booths can be spaced with appropriate distances from each other to form a sense of "place"

embly: Each "booth" is detached individually from each other, fully or almost fully assembled before transporting to site,
uiring minimum installation by the project team members on site and can be transported in a small truck.

: Public gathering place, outdoor or indoor, e.g. city plaza, university campus, mall atrium, building lobby, fairground,
vention hall, museum and expo...

entation Media a) Posters and 2D presentation:
 b) Partial display of the actual products: the Phone Booths

ibits Dimension Vertical display posters- total area: 12 m2 (4 display boards of 3 square meter each)
 Floor display of products of booths: approximate 15-20 m2

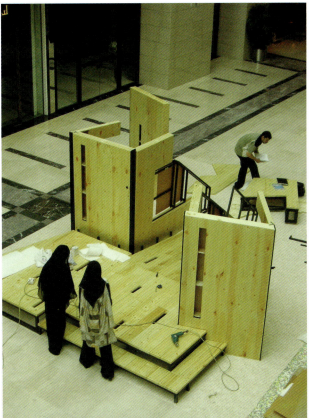

TeaCoffee
茶咖啡

Author ARCH 206 Design II, Class of Spring semester 2007
Yousef Abul, Abdulaziz Alkandary et al.

Faculty Adviser Quinsan Ciao

Pavilion: Center of inertia Pavilion

Students Team:
Mariam Akrof
Hawraa Al-Musawi
Fay Al-Osta
Farah Dashti
Abdulaziz Khalid
Mohammed Nahar
Yousef Abul
Yousif Al-Saleem

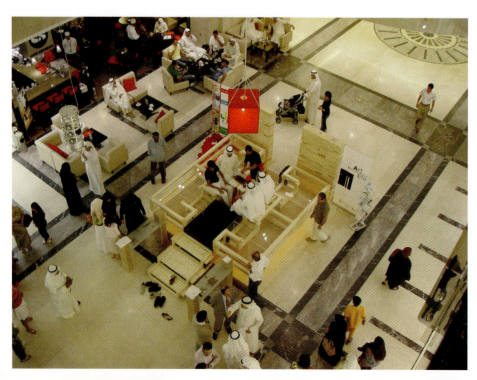

Pavilion: Floating Chi

Students Team:
Maram Al-Subai
Abrar Al-Qashan
Mohammed Al-Roomi
Abdulaziz Al-Kandry
Soud Al-Khalid
Ruba Al-Saleh
Saad Al-obaid
Yasmin Al-Othman

TeaCoffee
茶咖啡

Pavilion: Il-Mamar

Students Team:
Alanood Al-Zabi
Dana Taqi
Dalal Al-Buaijan
Badria Al-Adsani
Sara Abdulmalek
Osama Hadeed
Eman Al-Yousefi

Pavilion: "Wid"

Students Team:
Mubarak Al_Zeweer
Fajer Al-Sabah
Manal Al-Ajmi
Basma Al-Baghli
Jawad Al-Shakhs
Soud Al-Mutawa
Marzouq Al-Mutairi
Ahmed Al-Mizidi

Future Cookies [Imported] *Author* Karin Knott

Work Theme Description
The work consists of the boxes with the "ideal things" sending to different cities of the world, the recruitment wall mixed with the children's ideal, the celebration balloon printed with the children's ideal and congratulations for the cultural fair and the interview about the children.

Presentation Media Installation
Exhibits Dimension 16 boxes (box ca. 9x16x8cm)

Future cookies [imported]©
Self-Prognosticated Destiny
by Karin Knott/ 2008

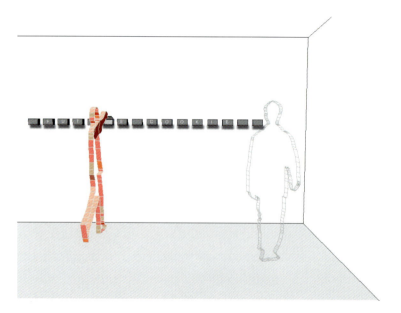

Sketch
Boxes (wall mounted)
to be opened at front
containing readable future cookies

Future cookies [imported]©
Self-Prognosticated Destiny
by Karin Knott, June 2008

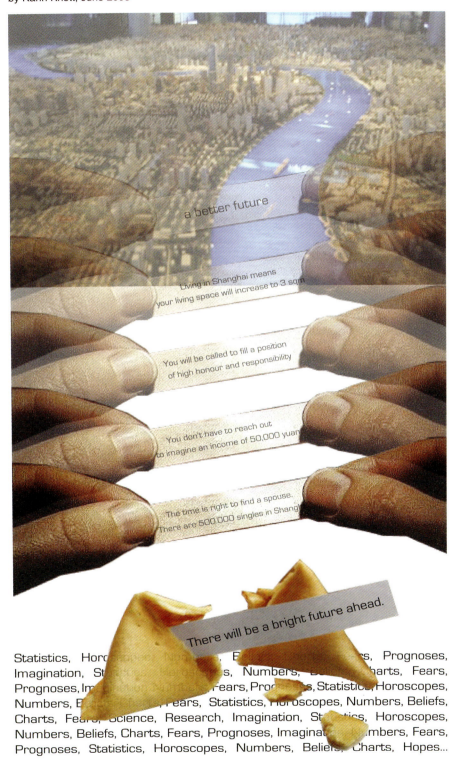

a better future

Living in Shanghai means your living space will increase to 3 sqm

You will be called to fill a position of high honour and responsibility

You don't have to reach out to imagine an income of 50,000 yuan

The time is right to find a spouse. There are 500,000 singles in Shanghai

There will be a bright future ahead.

Statistics, Horoscopes, Numbers, Beliefs, Charts, Fears, Prognoses, Imagination, Statistics, Horoscopes, Numbers, Beliefs, Charts, Fears, Prognoses, Imagination, Numbers, Fears, Prognoses, Statistics, Horoscopes, Numbers, Beliefs, Charts, Fears, Statistics, Horoscopes, Numbers, Beliefs, Charts, Fears, Science, Research, Imagination, Statistics, Horoscopes, Numbers, Beliefs, Charts, Fears, Prognoses, Imagination, Numbers, Fears, Prognoses, Statistics, Horoscopes, Numbers, Beliefs, Charts, Hopes...

Please note, the picture has to be shown with the written abstract.

同济大学：
张洋： maydayps@hotmail.com
朱慧： joyjo86@yahoo.com.cn
孙逢泽: Fengze.sun@gmail.com
沈思渊: Sigua1985@126.com
张思远： zsy_831@sina.com
王宣之： zoewxz870715@126.com
殷雯婷： greensky_yin9@hotmail.com
张晓钟 李佳砚 谢飞宇 周薇 薛晶 余芳： zwlcf@163.com
李维伊 陈烨： finlee@126.com

中国美术学院：
叶玲珠、项建恒： xiangjianheng@126.com
陈炼： Kanu1982@163.com
李甸： Lidian0526@126.com
应歆珣： xunxun798@126.com
陈华平： chpjzs@yahoo.com.cn
黄光辉： lice200266@hotmail.com
杨俊岭： djart@sina.com
陈志远： zhiyuan302@hotmail.com
卢意： Luyi310009@yahoo.com.cn
邵文欢： Wenhuan_9@yahoo.com.cn
宋振： Songzhen127@hotmail.com
赵婧妍： ZHAOJINGYAN726@hotmail.com
竺斯昀： zhuzhu_yixiang@hotmail.com

中央美术学院：
叶云： yey1986@163.com
张文超: Wenchaozhang682@msn.com

汕头大学长江艺术与设计学院：
童斌锋: tbfvision@163.com
陈秋涛: S_qtchen1@stu.edu.cn

东华大学：
张艳： Cola886@126.com
舒玥： nancyshuyue@126.com
顾文文: Vivi1123zr@126.com

上海戏剧学院：
高原： gy19850717@126.com

东南大学：
汪皆瑞: alwaysjerry11@gmail.com

广州美术学院：
许慧晶: Xuhuijing_523@yahoo.com.cn
钟爱： zaza16291629@hotmail.com

广东商学院：
侯海莹 梁伟斌 林旭熙： imlayla@126.com

西安建筑科技大学：
田禾： horantian@gmail.com

苏州工艺美术职业技术学院：
柳旭： mummy1010@tom.com

山东艺术学院设计学院：
徐中文： guichinuoxi@yahoo.com.cn

天津美术学院：
肖金志: xjz0503@tom.com

上海大学、华东师范：
余璐、章惠博： menthae@163.com

上海大学：
李鹏飞: ideal1007@163.com

杭州师范大学美术学院:
荆萃: ztwn@yeah.net

湖南大学:
张叶子、陶醉: tacduolc@gmail.com

University of Lethbrdge:
LuoYan: meishuben@hotmail.com

The University of The Arts London, Central Saint Martins College of Art and Design:
黄晓路: hxlfanny@163.com

Birmingham Institute of Art and Design:
YanGu: camillegy@yahoo.com

Royal College of Art, London, UK:
Chris Holden : Chris_holden@hotmail.co.uk
Menno Kroezen: mennokroezen@googlemail.com

School of Art RMIT University:
SUMMERS FLEUR: fleur.summers@mail.edu.au
Robin Kingston: robin.kingston@mail.edu.au

University of Tehnology, Sydney:
陆怡颖: helloyiying@gmail.com

Escuela de Diseñoy Comunicación Visual – ESPOL:
MAURO ROJAS MUÑOZ: mauro-rojas@hotmail.com

Lucerne University of Art and Design (HSLU):
Jonas Baumann: jonas.baumann@stud.hslu.ch

New York University:
Griffin Frazen: griffinfrazen@gmail.com

University of Dundee:
Alison Thomson: athomson@computing.dundee.ac.uk
Andrew Stevenson: andrewstevenson6@hotmail.com
Craig Gallacher: CRAIG.GALLACHER@GMAIL.COM
Dalius Ripley: dalius007@hotmail.com
Dave Anderson: dave.anderson.84@gmail.com
GavinPettigrew: gwpettigrew@live.co.uk
Nicola McCabe: Nicola_mccabe@hotmail.com
Ross Brown: rmzbrown@googlemail.com
Victoria Marshall: marshall_victoria@hotmail.co.uk

The University of Art and Design Helsinki:
Mr Paakkanen, Mikko; Ms Pokela, Laura; Mr Laakkonen, Mikko; Mr Salonen, Jussi; Ms Kosonen, Krista; Ms Kurahara, Tokomo; Mr Aalto, Klaus; Ms Nuutinen, Paula; Ms Huber, Sasha; Mr Tolonen, Hese:
Timo.salli@taik.fi
Mr Suomala, Timo; Mr Santamala, Harri: raimo.nikkanen@taik.fi
YRJÖ SOTAMAA: yrjo.sotamaa@taik.fi

Kuwait University:
ARCH 206 Design II, Class of Spring semester 2007
Hamad Hulaibi et al. qciao@hotmail.com
ARCH 206 Design II, Class of Spring semester 2007
YousefAbul, Abdulaziz Alkandary et al. qciao@hotmail.com

ECOLE De DESIGN NANTES ATLANTIGUE:
MAUD-ANDREA BIDET: MA.BIDET@LECOLEDEDESI

2008上海双年展国际学生展组织架构
主办：　　上海双年展组委会
承办：　　同济大学建筑与城市规划学院
协办：　　清华大学美术学院
　　　　　中央美术学院
　　　　　中国美术学院
　　　　　上海大学美术学院
　　　　　创智天地
赞助：　　同济大学建筑设计研究院
　　　　　上海同济规划设计研究院
　　　　　上海现代设计集团
　　　　　五合国际
学术委员会：
方增先（中国）：　　　上海美术馆馆长
潘公凯（中国）：　　　中央美术学院院长、教授
许江（中国）：　　　　中国美协副主席，中国美术学院院长、教授
吴志强（中国）：　　　同济大学建筑与城规学院院长、教授，2010年世博会总规划师
李当岐（中国）：　　　清华大学美术学院教授
汪大伟（中国）：　　　上海大学美术学院常务副院长、教授，上海美术家协会副主席
李磊（中国）：　　　　上海美术馆执行馆长
吴国欣（中国）：　　　同济大学建筑与城规学院艺术设计系主任、教授
张晴（中国）：　　　　2008年上海双年展策展人团队总策展人
约里奥·索达曼（芬兰）：芬兰赫尔辛基艺术设计大学校长、前CUMULUS国际艺术设计与媒体院校联盟主席
朱里安·翰尼（德国）：　2008年上海双年展策展人
翰克·斯劳格（荷兰）：　2008年上海双年展策展人

International Students Exhibition of Shanghai Biennale 2008
Host:
The organizing committee of Shanghai Biennale 2008
Organizer:
College of Architecture &Urban Planning, Tongji University
Associate Organizer:
Art College of Tsinghua University
China Academy of Fine Art
China Academy of Art
Art College of Shanghai University
Knowledge & Innovation Community
Sponsor:
Architectural Design & Research Institute of Tongji University
Shanghai Tongji Urban Planning & Design Institute
Shanghai Xian Dai Architectural Design Group
5+1 Werkhart International

Academic Committee:
FANG Zengxian (China):　Head of Shanghai Art Museum
PAN Gongkai (China):　　Rector of China Academy of Fine Art ,Professor
XU Jiang (China):　　　　Vice President of China Artists Association, Rector of China Academy of Art
WU Zhiqiang (China):　　Dean of CAUP, Tongji University, Professor, Chief Planner of EXPO 2010
LI Dangqi (China):　　　 Professor of Art College of Tsinghua University
WANG Dawei (China):　 Executive Dean of Art College of Shanghai University, Professor, Vice President of Shanghai Artists Association
LI Lei (China):　　　　　Executive Director of Shanghai Art Museum
WU Guoxin (China):　　 Head of Art & Design Department, CAUP, Tongji University, Professor
ZHANG Qing (China):　　Artistic Director of 2008 Shanghai Biennale
Yrjö Sotamaa (Finland):　Rector of Art & Design University of Helsinki, former president of CUMULUS
Julian Heynen (Germany): Curator of 2008 Shanghai Biennale
Henk Slager (Netherland): Curator of 2008 Shanghai Biennale

2008上海双年展国际学生展作品选
编委（按姓氏笔画排序）：
朱钟炎、吴志强、吴国欣、张建龙、陈健、范圣玺、周锐、赵月、俞李妹、娄永琪、殷正声、黄英杰
主编：吴长福、陈永群
版面设计：陈永群 李维伊 周薇 余芳 朱慧

Selected Works of International Students Exhibition of Shanghai Biennale 2008
Editorial Committee:
CHEN jian, FAN Shengxi, HUANG Yingjie, LOU Yongqi, WU Guoxin, WU Zhiqiang, YIN Zhengsheng, YU Limei, ZHANG Jianlong, ZHAO Yue, ZHOU Rui, ZHU Zhongyan
Chief editor: WU Changfu, CHEN Yongqun
Lay-out design: CHEN Yongqun, LI Weiyi, ZHOU Wei, YU Fang, ZHU Hui

2008上海双年展国际学生展策展团队
策展顾问：张晴、翰克·斯劳格
策展人：娄永琪、陈永群、莫娇
展览展示设计：谭靖漪、俞培晃、施胤
展览VI设计：杨皓

Curator Team of International Students Exhibition of Shanghai Biennale 2008
Consultant Curator: ZHANG Qing, Henk Slager
Curator: LOU Yongqi, CHEN Yongqun, MO Jiao
Display design: TAN Jingyi, YU Peihuang, SHI Yin
VI design: YANG Hao

图书在版编目(CIP)数据

快城快客：2008上海双年展国际学生展作品选/吴长福，陈永群主编．－北京：中国建筑工业出版社，2008
 ISBN 978-7-112-10310-2

 I.快… II.①吴…②陈… III.艺术-设计-作品集-中国-现代 IV.J06

中国版本图书馆CIP数据核字(2008)第133519号

责任编辑： 徐 纺
责任校对： 李品一

快城快客： 2008上海双年展国际学生展作品选
吴长福 陈永群 主编
*
中国建筑工业出版社出版、发行（北京西郊百万庄）
新华书店 经销
上海界龙艺术印刷有限公司 制版、印刷
*
开本：889×1194毫米 1/16 印张：10 $\frac{1}{8}$ 字数：246千字
2008年9月第一版 2008年9月第一次印刷
印数：1—2000册 定价：88.00元
ISBN 978-7-112-10310-2
 （17113）

版权所有 翻印必究
如有印装质量问题，可寄本社退换
（邮政编码 100037）